Theology of Contemporary Art

Félix Hernández Mariano OP

A Forum for Theology in the World
Volume 5, Issue 1, 2018

A Forum for a Theology in the World is an academic refereed journal aimed at engaging with issues in the contemporary world, a world which is pluralist and eucumenical in nature. The journal reflects this pluralism and ecumenism. Each edition is theme specific and has its own editor responsible for the production. The journal aims to elicit and encourage dialogue on topics and issues in contemporary society and within a variety of religious traditions. The Editor in Chief welcomes submissions of manuscripts, collections of articles, for review from individuals or institutions, which may be from seminars or conferences or written specifically for the journal. An internal peer review is expected before submitting the manuscript. It is the expectation of the publisher that, once a manuscript has been accepted for publication, it will be submitted according to the house style to be found at the back of this volume. All submissions to the Editor in Chief are to be sent to: hdregan@atf.org.au.

Each edition is available as a journal subscription, or as a book in print, pdf or epub, through the ATF Press web site — www.atfpress.com. Journal subscriptions are also available through EBSCO and other library suppliers.

Editor in Chief
Hilary Regan, ATF Press

A Forum for Theology in the World is published by ATF Theology and imprint of ATF (Australia) Ltd (ABN 90 116 359 963) and
is published twice or three times a year.
ISSN 1329-6264

ATF Press
PO Box 504
Hindmarsh SA 5007
Australia
www.atfpress.com

Subscription Rates 2018

Print	On-Line	Print and On-line
Aust $65 Individuals	Aus $55 individuals	Aus $75 individuals
Aus $90 Institutions	Aus $80 individuals	Aus $100 instiutions

ISBN: 978-1-925643-99-2 (paperback)
 978-1-925872-04-0 (hardback
 978-1-925872-05-7 (epub)
 978-1-925872-10-1 (pdf)

Front cover: Art by Kim En Joong, with permission of Institute Kim En Joong.

Back cover, Kim En Joong OP and Félix Hernández OP, Madrid 2018.

For full inventory of Pe Kim En Joong's paintings, ceramics and stained glass windows (with the church's in which they can found), please go to www.kimenjoong.com

Theology of Contemporary Art

Kim En Joong OP

Félix Hernández Mariano OP

Translated by Yanette Shalter

Adelaide
2018

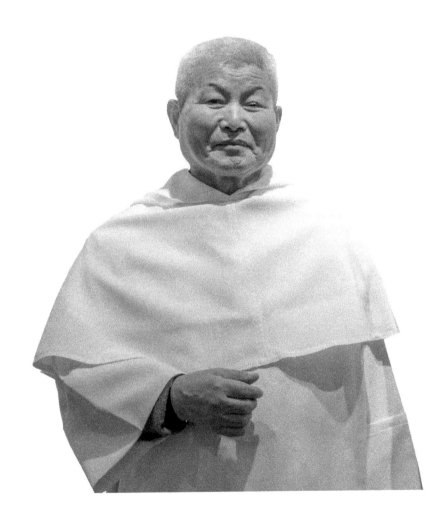

To my parents, my siblings, Rafa and Luis

Table of Contents

Abbreviations		xi
Acknowledgments		xiii
1.	**Introduction**	1
2.	**Biography**	5
	Youth and Childhood	5
	The Artist	7
	A Catholic and a Dominican	10
	Maturity and Artistic Success	14
	Personal Exhibitions	17
3.	**Artistic Work**	25
	Abstraction	26
	Preliminary Preparation	32
	Pictorial Elements	34
	Influences	38
4.	**Commentaries on the Works of Kim En Joong OP**	49
	Proposal of Active Participation	51
	Proposal of Mystic Spirituality	55
	Proposal of Dialogue and Search for Truth	60
	Proposal of Joy and Optimism	66
	A Significant and Modern Proposal	69
5.	**Corollary**	73
6.	**Bibliography**	75

Abbreviations

AA.VV.	Various Authors
AAS	*Acta Apostolicae Sedis*
ASS	*Acta Sancta Sedis*
BAC	Biblioteca de Autores Cristianos
CCath	Corpus Catholicorum (Münster)
CChr CM	Corpus Christianorum. Continuatio Mediaevalis (Turnhout).
CIC	Catechism of the Catholic Church
Ct	Canticle of Canticles
Col	Colossians
DS	Denzinger-Schonmetzer, Enchiridion Symbolorum.
Dt	Deuteronomy
DV	*Dei Verbum*
Ef	Ephesians
EG	*Evangelii Gaudium*
Flp	Phippians
Gal	Galatians
Gn	Genesis
GS	*Gaudium et Spes*
Hch	Acts of the Apostles
Jn	Gospel of Saint John
Job	Job
Lc	Gospel of Saint Luke
LF	*Lumem Fidei*
LG	*Lumem Gentium*
Mal	Malachai
Mc	Gospel of Saint Mark

MD	*Mediator Dei*
MG	Migne, Greek Patrology (Paris)
ML	Migne, Latin Patrology (Paris)
Mt	Gospel of Saint Matthew
OGMR	General *Ordenation of the Roman Missal*
Os	Isiah
OP	*Ordo Praedicatorum (Order of Preachers)*
PG	Greek Patrology
PL	Greek Patrology
Prov	Proverbs
Rom	Letter to the Romans
Rut	Ruth
Sab	Wisdom
Sal	Psalms
SC	*Sacrosanctum Concilium*
SCG	*Suma Contra Gentiles*
ST	*Suma Teológica*
St	Letter of James
1Cor	First Corinthians
2Cor	Second Corinthians
1Jn	First John
2Pe	Second Peter
2S	Second Samuel

Acknowledgments

This work, the result of a personal dream, would not have been possible but for the help of a great number of people to whom I am and my sincere thanks.

Thanks to my family and friends who have sustained me during this time, with their care, and when necessary, they have been my motivation and strength.

Importantly also has been the collaboration of my Dominican brothers and sisters: friars of my community, of my province, and some from far away; Dominican nuns, laity, sisters and young people who have animated me, and helped with many things.

My especial thanks to Fr Kim En Joong OP, who shows us with his art the beauty of God, the Institute Kim En Joong and his great friend and brother, Fr Nicolas Jean Sed OP, for his fraternity and attention with which he has attended to me.

My thanks must also go to Hilary Regan of ATF Press, who from the beginning believed in this project and who has not tired in making sure these pages have seen the light of day and to Yanette Shalter for her dedication and elegance with which she has translated this work into English.

Last, my sincere thanks to Fr Luis Aurelio García Matamoro OP, who directed my doctoral thesis from which this work has been adapted, for his unconditional presence, his confidence and orientation, without which I would never have finished this work.

And thanks, above all and always must go to God, the Great Artist, who has put all of these people in my life.

Félix Hernández Mariano OP
Sevilla, August 2018

Introduction

I was a student, thinking about a subject for my thesis in theology, when I learned about Kim En Joong. I was interested in studying the relationship that exists between art and theology when Fr Juan Manuel Almarza OP, who at the time was my studies advisor and a great admirer of Pe Kim, insisted that this name could not be omitted from my study.

So I discovered this artist via an Internet page, and I became totally fascinated by his work from the very moment his first painting appeared before my eyes on the computer screen.

Since that day, a lot of time has gone by, years during which I have explored the captivating universe of Pe Kim's artistic productions, following him in a near-obsessive way, delving deep into his work and getting to the bottom of his message with great excitement. And thus, little by little, I went from one discovery to another, finding gifts concealed by the 'artist of light' in each of his canvases, for observer to discovery of a entire depth of meaning.

Step by step I was able to verify that, in each of his creations, Pe Kim offers us a true theological reflexion which, in addition to being in tune with the theological demands and endeavours of our times, lays the foundations of a bridge between the ecclesiastic and artistic spheres—a connection of crucial importance in today's world. By doing this, he sets himself in the continuity of a rich tradition of Dominican artists who, throughout eight centuries of existence, have always succeeded in using their paintbrushes to penetrate and express the fathomlessness of God. They have served as a channel of communication between the Church and society, collected the

needs and expectations of their contemporaries, and offered faithful answers by means of a language that was both accessible and significant in each historical period.

I eagerly allowed the artist guide me along the lines of abstraction. He presented them to me as an exceptional language to communicate the experience of transcendence, which always lies beyond any concretion (concrete situation) or boundary. In this sense, these paths still largely remain to be explored . . . Paths of freedom, fit to genuinely offer the fruits of spirituality. In his paintings, stained-glass windows, and ceramics, Kim En Joong captures the richness of his inner life so that the spectator can also identify a spirituality of his own, which so often gets pushed to the background by the hurries (constant movement) and concerns of our fast-paced world. Thus he acts like a mirror in which we can recognise ourselves under a new light, namely that of the human and personal mystery.

This is why Pe Kim's suggestion (work) is universal: it speaks to all human beings, of all faiths and (all) beliefs.

I feel I have a lot for which to thank my brother Pe Kim. Though I have been researching his work for a while, his paintings still take my breath away, and his art continues to be an endless source of inspiration for me. It preaches in a contemporary, yet authentically Dominican way. This announcement of grace is formulated with the faith necessary to dare look at the future with decisiveness, without fear or insecurity. It is expressed with love, calling to respect each and everyone's freedom, and with the serene joy of him who knows where he has placed his hopes. The present-day world, our world, is desperately in need for all this . . .

Last, Pe Kim also brings a breeze (breath) of inspiration and encouragement to all the artists of the Order of Preachers—and of the Church in general—whose works are generally under-valued. Compared with conceptual reflections in written words, they are often considered 'second-rate'. But the example at hand shows us that this is not the case, that art is not merely an ornamental support but a language in itself, and one that is perfectly efficient to deal with matters of theology.

This is how, year after year, Pe Kim became the main character of my doctoral thesis. Today I remain committed to bringing his work to light for all our contemporaries, in both religious and secular spheres.

This dissertation (book) is an extract of my studies, of all that I have learned and enjoyed throughout this whole period. I wish to share with the reader the capitalised 'YES' that is Kim En Joong's art: yes to God, yes to the human being and his mystery, yes to the worlds of today and tomorrow, to opening the door to dialogue, to unity, hope, and light.

Biography[1]

Childhood and Youth

Kim En Joong was born into a large family on 10 September 1940 in Booyo,[2] South Korea, during the Japanese occupation.[3] His father, a humble calligrapher, took care of his eight children and brought them up in line with the Taoist tradition.

Nothing during his early childhood suggested that, one day, he might feel attracted to the arts. His family's material living conditions did not leave any space for such concerns either; their only worry, at the time, was survival.[4]

Just like other children, Kim spent his first years running happily through fields speckled with modest straw houses, jumping over streams and shouting across rice paddies with other boys of his age. Although he was still unaware of the daily deprivations and misery that forty years of Japanese occupation had caused in his village, he did know what hunger felt like. However, the love of his kin and the wisdom of his people compensated for all the material shortages.

1. There is no Spanish bibliography for this author, which is why most of the quotes about him are personal translations. Since the phrasing is generally quite poetic, I chose to add the original texts as footnotes, so that the reader can collate them if he or she wishes to do so. There are also only a few books in English
2. A small town in the province of Choong Nam.
3. The Korean peninsula was occupied by Japan from 1910 to the end of World War Two, but after the Japanese Empire's unconditional surrender on August 15th, 1945, the USA divided the peninsula following the 38th parallel; the Northern part remained occupied by Soviet troops and the Southern part, by US troops.
4. JC Pichaud, *Kim En Joong et le Cabanon de Saint-Paul* (Paris: Cerf, 2013), 21.

Another important event that marked our artist's childhood was when he discovered the reality of death, namely that of his grandmother. In his family's house, the weeping, the ceremonial, the superstitions, the long rituals, the incomprehension of it all filled him with terror and affliction. The presence of ancient, often mortal gods, living amidst nature, did not suffice to dissipate the child's fears.

The presence of death mixing in with beauty at any moment, this idea of nothingness never left him throughout his teenage years;[5] it sowed a series of questions in his mind, of human and religious concerns to which he was to find no answers until many years later. One of his biographers wrote the following: 'By resisting death and oblivion, Kim, then a fifteen-year-old teenager, came to yearn to not disappear from the world of the living without leaving a trace of his passage; this longing for success and recognition lasted throughout time.'[6]

In 1946, with the liberation of Korea and the Japanese retreat, the family moved to Daejeon.[7] The boy experienced this move with emotion, fascinated by all the novelties offered by the city: in the shop windows he discovered electric light and colourful printed magazines left behind by the invaders.[8] Between 1947 and 1959, he attended primary and secondary school.

This was when what is known as the 'Korean War' broke out[9] and the horror of violence, the refugees' calamity, death and ruin once again struck the young man's life. This experience reinforced the feeling of precariousness that accompanied Kim for years, but over time, he forged a deep desire to achieve some success that would transcend death.

5. Pichaud, *Kim En Joong et le Cabanon de Saint-Paul,* 21

6. 'Résister à la mort, à l'oubli, conduisait Kim, l'adolescent de quinze ans, au sentiment qu'il lui était impossible de disparaître du monde des vivants sans laisser une trace de son passage; ce souci de succès, de reconnaissance se prolongeant dans le temps.' Pichaud, *Kim En Joong et le Cabanon de Saint-Paul,* 23.

7. Located in the centre of South Korea, 167 kilometres South of Seoul, it is the capital of the province of Southern Chungcheong. With approximately 1.5 million inhabitants, it is the fifth largest city of South Korea.

8. AA.VV, *Kim En Joong* (Paris: Cerf, 1997), 19.

9. After the division subsequent to World War Two, the tension between the two Koreas grew until North Korea invaded South Korea on 25 June 1950, in what was considered the first serious armed conflict of the Cold War. In 1953 the war ended with an armistice which restored the border between the two Koreas near the 38th parallel and created the Korean Demilitarised Zone, a four-kilometre-wide strip of land between the two countries.

Kim did not draw much in those days; at school he was merely asked to copy models from books, a chore he did not enjoy. Over the course of his secondary studies, art was not given much importance either. In a country that was just coming out of an armed conflict, priority was laid on language, mathematics and protest demonstrations against the state of the torn land. At that time, one hour per week even had to be dedicated to military training in view of defending the nation against communists.

In spite of all this, in secondary school, Kim started practising the art of calligraphy at the age of twelve and painting watercolours at seventeen. While he developed these skills, his admiration for his father, who worked in a textile company at the time, played a decisive role. Kim would attentively observe his meticulous work, the delicacy with which he would ready his instruments, the precision of his purposeful moves.

His first works were immediately recognised by his teachers, who encouraged him to orient his career toward the graphic arts. Between the ages of sixteen and eighteen, he followed optional drawing courses taught by a secondary school teacher who helped a group of pupils outside of the official curriculum to prepare for the entrance exams of the School of Fine Arts.

His parents' reaction upon discovering their son's intentions was not a positive one; they felt disappointed, because they had hoped he would take up a less precarious profession which would enable the family to overcome its financial difficulties. This was not a particularly stimulating period for youngsters interested in fine arts, as such studies were not considered to lead to well-paid positions.

In spite of all this and of the fact that Kim believed he was artistically less gifted than his classmates, he prepared for and took the entrance exam to University. In 1959 he was admitted to the School of Fine Arts of Seoul.

The Artist

His four years of studies were interrupted by the revolution[10] of the art students in 1960, and then by the requirements of a very strict military training that took place between 1961 and 1962 in the school itself.

10. South Korea experienced political unrest during the years of the autocratic leadership of Syngman Rhee, which climaxed with a student revolt in 1960.

Those were hard times due to the financial hardships of his family. Kim had very little money and had to come up with his own materials. He prepared his paints himself by mixing pigments with petroleum, and he made his own canvases by sewing together North American bags of flour. Since he did not have any secure place to store his work, his entire production over that period was lost.

This was also, however, the period during which Kim discovered a whole new world thanks to young teachers who were returning from Paris. Western modern art with all its teachings, movements, tendencies—Impressionism, Cubism—and above all, its none-figurative vision of painting immediately captivated his soul:

> How can one not think about Worringer's reflection who, in 1908, wrote that 'the power of abstraction is the consequence of a great inner turmoil, caused in man by phenomena of the outside world'? As Dora Vallier so acutely analyses, the young German had observed that 'the uncertainty of life experienced as a threat diverts man from reality; in such moments, his sensitivity is retained by that which is out of touch, and art tends towards abstraction since only the abstract form can transcend reality'. Considering the tragedies suffered by Kim and the misery he endured, it is easier to understand the strong impulse which led the young man to leave the sombre reality and to imagine a new world, more in keeping with his dreams.[11]

The great efforts he made during those years paid off. His mentors began to show interest in Kim's work and, in 1962, two successes confirmed the path he had chosen. He managed to be among the three best entrants in a contest opened to young painters, organised by a Korean newspaper on the occasion of a modern art exhibition, and

11. 'Comment ne pas songer à cette réflexion de Worringer qui en 1908 écrivait que «la poussée de l'abstraction est la conséquence d'une grande inquiétude intérieure chez l'homme provoquée par les phénomènes du monde extérieur» (L'Art abstrait, p. 21)? Comme l'analyse si finement Dora Vallier, ce jeune Allemand avait observé que «l'incertitude de l'existence ressentie comme une menace détourne l'homme du réel; à de tels moments, la sensibilité étant retenue par ce qui est hors d'atteinte, l'art tend vers l'abstraction, car seule la forme abstraite peut transcender le réel». *Ibid.* Face aux drames vécus par Kim, aux misères supportées, on comprend mieux l'énergique élan qui pousse le jeune homme à quitter les sombres réalités pour imaginer un monde nouveau plus conforme à ses rêves. Pichaud, *Kim En Joong et le Cabanon*, 27.

he won the special award for non-figurative artworks in the contest of the 1962 annual exhibition.

Then came his time to serve in the military, which lasted from 1963 to 1965. Commissioned in 1963 as second lieutenant in the infantry, he underwent a three-month training before he was sent to the front.

Kim served during the Vietnam War, on the border between the two Koreas[12] where he suffered tremendously from the division of his country. This war led him to understand the true meaning of death.

In the army he dedicated much time to sports (volleyball), but above all to his great passion. He drew a lot and was even able to present some of his works at the following annual exhibitions. In addition, with the intention of pursuing his university education, he prepared for and took the exam which opened the door to a graduate course, and he started studying French.

At the end of his military service, he was strongly encouraged to continue painting by a United States of America art critic who published a laudatory article in the newspaper of the capital, in which he asserted that Kim's was the best among all the works exhibited in the national painting contest: 'Kim has brought together the world of Miró and the subject matter of Dubuffet.'[13] On top of this, the expert highlighted the fact that the painting submitted by our artist alone made it worth-while to visit the exhibition.

Thus, relieved of his military duties, Kim decided once and for all to dedicate himself to painting:

> These various incentives consolidated his idea that he was forever 'married' to painting; in his art he found the first glimmers of recognition; his willingness to exist, to accomplish himself and perhaps to live on beyond his own death was finding here the beginning of an answer. This unquenchable source of satisfaction, his only passion, nothing else seemed to exist in this desert of love.[14]

12. *Cf* J Thuillier, *Kim En Joong—Peintre de lumière* (Biographie) (Paris: Cerf, 2004), 62.

13. AA.VV, *Kim En Joong*, 23.

14. Ces divers encouragements le confortaient dans l'idée qu'il était, à jamais, «marié» avec la peinture ; elle seule lui apportait les premières lueurs de reconnaissance ; sa soif d'exister, de se réaliser et peut-être de durer après sa mort trouvait ici un début de réponse. Source inépuisable de satisfactions, unique passion, rien d'autre dans ce désert de l'amour ne semblait exister. Pichaud, *Kim En Joong et le Cabanon*, 32.

A Catholic and a Dominican

Yet he also needed to find a job that would enable him to earn a living. In 1965 he got (was) hired as a drawing teacher's assistant in the Catholic Youth Seminary of Seoul. It was in this minor seminary that he first felt the draw of transcendence and spiritual life.

One morning as he was arriving as usual to teach his classes, he stopped in front of the Hai Wha church. Curiosity first led him to enter the temple, but then the beauty of the liturgy seduced him in such a way that he got used to attending the celebrations daily. He was greatly surprised to discover catholicism and attended each ceremony attentively. In this atmosphere he could feel the mystery of this unique God, the death and resurrection of his son Jesus, the immortality of souls, the commandments which had unknowingly guided him throughout his life, and the message of love. Everything delighted him in such a way that, little by little, he was overtaken by the desire to explore Christianity more in depth. This aspiration overwhelmed him with the same force as had his passion for art in the past.

Thanks to this encounter he finally found answers to the spiritual concerns that had accompanied him since childhood.

He sensed a new dimension, the ever-growing presence of another world, another eternity, which put into perspective all the aspirations he had hosted so far. And the cross,[15] the mystery of a God who knows human pain, who suffers and who dies, filling our precariousness with meaning and life, was decisive when, in early 1967, Kim asked to be baptised. He received this sacrament on 28 June 1967.

Meanwhile, as he went deeper into his conversion process, he also received more and more recognition as an artist.

In 1965 he was awarded the first prize of a Korean exhibition in Pusan, and in 1967 he set up his first individual exhibition, where he sold various paintings.

At this point Kim was torn between his two passions: art and a new idea that was making its way ever more deeply into his soul . . . the will to dedicate his life to God. The artist did not know yet whether it was going to be possible to reconcile the two or whether, on the contrary, he would have to sacrifice one for the other:

15. Personal interview with Fr Nicola Jean Sed, OP, a close friend of the artist and Vice President of the Institute Km En Joong.

Look, we have left everything to follow you (Mt 19:27); these words of the Gospel were disconcerting for Kim, the artist; indeed, he figured art should not be placed so high in one's preoccupations that some minds might consider the Art-God as a rival to the real God! But this was not a combat like the one depicted by Delacroix, that fight between Jacob and the Angel which he was to discover later in one of the Saint-Sulpice chapels in Paris. For Kim, on the contrary, far from being a rival, art was at the service of God; a sublime way of singing his glory, it was first and foremost a prayer. To sacrifice art to religion? He was unable to contemplate such a perspective; like the young Claudel he could have whispered: 'My art, God alone could fathom the hugeness of the sacrifice'. (Letter to André Gide, 1905).[16]

The year 1969 marked another turning point in his life. Kim became aware of an ambition that had been growing in his inner self since his years of higher education: to study and settle in Europe. This intimate desire started to take shape when he received a scholarship from the University of Fribourg, Switzerland. Hoping to find some answers to his vocational doubts on the new continent, Kim embarked on the adventure with nothing but his plane ticket and a hundred-dollar bill in his pocket.

After a three-day journey he landed in Paris where he remained for three more days thanks to the selfless help of various people, whom he randomly met along the way. In 1969 he arrived in Fribourg where he established his residence. To earn a living he worked during the summer holidays in Bern and later in Zurich, as a night watchman.

16. 'Voici que nous avons tout quitté pour te suivre (Mt 19, 27); ces paroles de l'Évangile laissaient rêveur Kim, l'artiste; en plaçant si haut l'art dans ses préoccupations, il ne fallait pas, songeait-il, que certains esprits aillent jusqu'à considérer le dieu-art comme un rival du vrai Dieu! Il ne s'agissait pas d'un combat comme celui peint par Delacroix, cette Lutte entre Jacob et l'Ange qu'il découvrira par la suite dans l'une des chapelles de Saint-Sulpice à Paris! Pour Kim, loin d'être un rival, l'art était au contraire au service de Dieu; moyen sublime pour chanter sa gloire, il était, avant tout, une prière. Sacrifier l'art à la religion? Il ne pouvait envisager une telle perspective : comme le jeune Claudel il aurait pu murmurer: « Mon art, Dieu seul pouvait connaître l'énormité du sacrifice » (Lettre à André Gide, 1905).' Pichaud, *Kim En Joong et le Cabanon*, 32.

Once enrolled in the University of Fribourg, the young man soon left the Department of History of Art, because those classes did not meet his expectations. Instead, he went as an unregistered student to attend theology classes, which he followed with diligence and interest, especially the metaphysics courses taught by Fr Geiger OP, a Dominican whom Kim admired deeply for his human and religious qualities.

Shortly thereafter, at an exhibition in Fribourg, he also met Fr Pfister OP, a teacher of Dominican students who was charmed by the young man's work and who invited him to his convent, offering him a space in the basement to use as a study. At this moment, in the artist's heart, an invisible thread seemed to appear, like a hyphen between his first passion and the new one, drawing him to the Absolute. This link was nourished by the attitude of his brothers toward contemporary art:

> The fact that the Dominicans were on the front line of what is called 'the resurrection of sacred art' was not meaningless in Kim's final decision to accept or to refuse his double commitment. Given the divorce between art and the Christian faith, a separation which began at the end of the Middle Ages, the brave action of Fathers Couturier and Régamey with the journal *Sacred Art* was necessary to awaken people's consciences in the 1930s, after Maurice Denis, with Fr Sertillanges; some, like Fr Régamey, reserved sacred creation to 'those who live off Christ' like Fra Angelico in times past; others excluded no one, like Fr Couturier who wrote that "between the mystic inspiration and that of heroes and great artists, there is too deep an analogy to not let favourable prejudices shine a positive light onto them [. . .] The artist who achieves the miracle of appropriately evoking matters of faith in believers, is he moved by faith himself? Who shall grant or deny this to him? Let us not pretend to penetrate the secret of the hearts, and let us not usurp the judgement of God' (*The Journal of Sacred Art*).[17]

17. 'Que les Dominicains aient été en première ligne dans ce que l'on appelle « la résurrection de l'art sacré » ne fut pas sans influence sur la décision finale d'accepter ou de refuser le double engagement de Kim. Face au divorce entre l'art et la foi chrétienne, séparation remontant à la fin du Moyen Âge, il fallut, dans les années 1930, après Maurice Denis, avec le père Sertillanges, la courageuse

One year later, after many intense meetings, conversations, and long considerations, Kim ended up applying to enter the Order of Preachers.

He did his noviciate in 1970 and continued painting. He took his vows for the first time in 1971 and the following year he was sent to Paris for two years to continue his studies at the *Institut Catholique*. During his stay he was deeply moved by the writings of Fr Sertillanges regarding life and death. He was also confirmed in his vocation by Fr Menasce who, against all those who believed it was impossible to be a priest and a painter at the same time, used to tell him: 'God respects what he has entrusted unto men. Carry on. Pray to Fra Angélico.'[18]

In the Dominican convent of the Annunciation he met Fr Avril and Fr Lelong who were to support him from then on in his efforts to mature in his work and life as a painter.

In the summer of 1973 he visited Alsace and Provence and, in December of the same year, he set up his first exhibition in Paris in the *Galerie Jacques Massol*, displaying watercolours and works on paper in black and white. Here, M Anthonioz purchased a work for the State.

Back in Fribourg in 1974 he made his solemn profession as a Dominican and was ordained as a priest on 27 October 1974. In November 1974, after going through Japan, he returned to Korea where he informed his family of his new life, and baptised one of his brothers and one of his sisters. A few months later, during the celebration of St Thomas Aquinas in early 1975, he baptised his parents.

When he returned to Europe in that same year of 1975, he was assigned to the Convent of the Annunciation in Paris: it became his home, and still remains so to this day.

action des pères Couturier et Régamey avec *la revue L'Art Sacré* pour réveiller les consciences; certains, comme le père Régamey, réservant la création sacrée à «ceux qui vivent du Christ» comme jadis Fra Angelico, d'autres, comme le père Couturier, n'excluant personne car, écrivait-il, « il y a dans l'inspiration mystique et celle des héros et des grands artistes une trop profonde analogie pour que le préjugé favorable ne joue pas en leur faveur [...] Tel artiste qui réussit le miracle d'évoquer comme il convient aux croyants les choses de leur foi, est-ce bien la foi qui l'anime? Qui osera la lui accorder ou la lui refuser? Ne prétendons pas pénétrer le secret des cœurs et n'usurpons point le jugement de Dieu » (revue *L'Art sacré*)'. Pichaud, *Kim En Joong et le Cabanon*, 41.

18. AA.VV, *Kim En Joong*, 24.

Maturity and Artistic Success

In December 1975, a second exhibition was held in the *Galerie J Massol*. Due to the great white surfaces of his paintings, he was tagged by M Cabanne[19] as 'the white painter'. When J Guichard-Meili wrote the introductory text for the invitation to the exhibition, he based it on this theme.

In turn, the *Galerie Benador* in Geneva also showed his work. This was his first exhibit outside Paris, 'Acrylic and white'. Kim's works contained such scant colour that some critics maintained he would soon be exhibiting completely white canvases . . . Kim reacted by introducing different shades into the white of his paintings.

In 1976 he worked as a chaplain in a convent on the Mediterranean coast, a landscape which struck him with awe. The quality of the light caught his attention, like in the world of Impressionism. There he met the Chave[20] couple and came into contact with the Maeght Foundation.[21]

During those years, due to his scant financial resources, he lacked materials and tried to work at a reduced cost. He continued using acrylic and in 1977 he made some collages in his convent cell. This was a tough period for Kim because he was not satisfied with his art, but in spite of everything he continued working in the same way. He wanted 'to dig ever deeper'[22] and to move forward.

On the occasion of a trip to New York in 1979, Kim found himself face to face with Americand visual art, which greatly influenced his own work.

Little by little, exhibits and recognitions started to add up. In 1982, the City of Paris' Museum of Modern Art purchased one of his works. That same year an exhibition took place in the Chave Gallery; the author Julien Green wrote the text of the invitation.

In 1983, he started producing large-scale works with oil on canvas.

19. An art critic who worked for the journals *Combat* and *Le Matin* in Paris, as well as for many art magazines, and for the radio station *France Culture*.

20. Peter and Madeleine Chave were the owners of a big gallery in Vence which had greeted great artists such as Matisse, Chagall, Braque, Dubuffet, Max Ernst, Man Ray and many others.

21. A private foundation established in Saint Paul de Vence. It owns one of the most important art collections in Europe and dedicates itself to the promotion of contemporary art.

22. AA.VV, *Kim En Joong*, 25.

Kim's work continues to be exhibited in many places, at significant galleries: Lausanne, Bern, Vence, Oslo and Luxembourg.

The year 1987 stands out as marking the beginning of a new activity: this is when Kim created his first stained-glass windows for the Church of St John Baptist in Angoulême. They were produced by M Charles Marq, Chagall's main glass manufacturer. From then on, he achieved dozens of creative projects involving stained-glass throughout France (Evry, Bénodet, Chartres, Lyon, Brioude, Thann . . .), but also abroad (Ireland, Italy, Austria . . .).

Two years later, in 1989, Kim also started working with lithography. Several series were initiated, and in 1991, the Chave Gallery produced 'Dreams of Colours', a collection illustrated with original lithographs, which was to be followed by a more modest edition.

The friar's artistic passion led him to thoroughly study many other materials such as ceramics, liturgic attire, etc. All his works were greeted by the public with enthusiasm.

From 1988 to 1996, exhibitions continued proliferating, often in prestigious establishments: in *Sylvanes*, where Fr Gouze was organizing a homage to Fr Couturier, in the Abbey of Fontfroide, in the Palace of the Popes in Avignon, in Santa Sabina, the General House of the Dominican Order, in Leningrad, Vienna, Bonn, in Sweden, in the Gallery *Fanny Guillon-Laffaille* in Paris.

The first of many books about Pe Kim was published by the *Ediciones du Cerf* in 1996: 'Fragments of an unknown world'. Julien Green,[23] whom the Dominican met in 1980, wrote a passionate praise about the artist's work; a deep friendship bound the two creators until the author's death.

This first book to be published was a significant moment as it was the start for Pe Kim En Joong to be known in France. Till then he had been a little known Dominican friar from Korea living in Paris doing his painting. He knew the value of his work and knew he was good, but others did not know him and he sold very little. Now a trajectory began which led to other books and his becoming known in France and Europe. Editions du Cerf, in Paris, through Nicolas Jean Sed OP,

23. Julien Green (1900–1998) was a writer of United States nationality, but who was born and lived in France. He is the author of various novels among which one can find *Leviathan* and *Each in His Own Darkness*; however, in France he was mainly known for his diaries, written between the years 1926 and 1976.

took the risk with being the main publisher and thus, promoter, of Pe Kim En Joong.

The intensity of all these experiences led to the fact that 1992 was a decisive year, as it saw the consolidation of the three main characteristics of his pictorial style: the abundance of colour, transparency, and calligraphy.

In the United States, Kim's paintings were shown at the Chicago Fair in 1993 and at the New York State Fair the following year. In Seoul, a major newspaper sponsored an exhibition, and to celebrate the twenty-fifth anniversary of his arrival in Europe, another exhibit was put up in Paris, at the Korean Cultural Centre.

At the end of 1996, Pe Kim inaugurated his first exhibition in Tokyo in the *Galerie Yoshii*, and in 1997 he was in Dublin at the Museum of Modern Art.

Another event that stands out in his career is the exhibition he held in 2003, in the cathedral *Notre Dame de Paris*, a homage to Mary and to John Paul II. All the paintings were presented together in a volume called *Ave Maria*, in which Belgium based Cardinal Godfried Danneels collaborated.[24]

In 2007, together with the master glass-maker Bruno Loira, Kim En Joong won a contest which fifty-four teams had entered to make the stained-glass windows of the basilica of Brioude. This is the largest work he has done so far: thirty-seven windows and 150 m² of stained glass. This work resulted in him being decorated with the insignia of Officer of the Order of Arts and Lettres by the French Minister of Culture Frédéric Mitterand, in August 2010.

In 2009 the Institute Kim En Joong was created with the objective of reflecting upon and administering the artistic legacy of our artist, as well as to accompany and promote artists in the spirit of Sacred Art.

From then on, Kim En Joong's creative process has not ceased to reap numerous successes; a great number of exhibitions have continued to present his new works in the cathedrals of Tours, Rouen, Lyon, Chartres, in the collegiate church of Saint-Thiebaut de Thann, in Tulle, Nantes and Paris.

24. Archbishop of Malinas-Brussels and President of the Episcopal Conference of Belgium between the years 1979 and 2010. He was raised to cardinalate in 1983.

Personal Exhibitions

1965:	Sin Moon Hoekwan Gallery, Seoul, Korea.
1973:	Galerie Massol, Paris, France.
1977:	Galerie Jacques Benador, Geneva, Switzerland.
1982:	Galerie Alphonse Chave, Vence, France.
1983:	Galerie Jean Fournier, Paris, France.
1986:	Galerie Kutter, Luxembourg. Galerie Alice Pauli, Lausanne, Switzerland.
1992:	Galerie Pudelko, Bonn, Germany. Galerie Fanny Guillon-Lafaille, Paris, France. Galerie Carinthia, Vienna, Austria.
1994:	Galleria Anna d'Ascanio, Rome, Italy. Cho Sun Ilbo Museum, Seoul, Korea.
1996:	Yoshii Gallery, Tokyo, Japan.
1997:	Municipal Gallery of Modern Art, Dublin, Ireland. Taylor Galleries, Dublin, Ireland. Musée d'Art Sacré, Évry, France.
1998:	Galerie Kutter, Luxembourg. Abbaye de Sylvanès, Camarès, France. Galerie Art-sélection, Zurich, Switzerland.

1999:	Le prieuré, Airaines, France.
	Le Château, Saint-Saturnin, France.
	Galerie Cazeau et de la Béraudière, Paris, France.
2000:	Taylor Galleries, Dublin, Ireland.
2000:	Galerie Yoshii, Tokyo, Japan.
	Santa-Sabina Convent, Rome, Italy.
	Galleria Anna d'Ascanio, Italy.
	Cho Sun Ilbo Museum, Seoul, Korea.
	Galerie Kutter, Luxembourg.
	Galerie d'art contemporain de Bécheron, Saché, France.
	Sainte-Ursanne, Switzerland.
	Église Perguet, Bénodet, France.
	Galerie Art-sélection, Zurich, Switzerland.
	Cathédrale Saints-Michel-et-Gudule, Brussels, Belgium.
	Église Saint-Roch et église Saint-Germain-l'Auxerrois, Paris, France.
2001:	Centro Umanistico Incontri Internazionale Antonio E Aika Sapone, Italy.
	Galerie Chave, Vence, France.
	Galerie Kutter, Luxembourg.
	Collège Saint Michel, Brussels, Belgium.
	La Collégiale Aire sur la Lys, France.

2002:	Grace Cathedral, San Francisco, USA. Taylor Galleries, Dublin, Ireland. Musée de Tulle, France. Les musées de Charlieu, France. Abbaye de Brantôme, France. Galerie Art-Sélection, Zurich, Switzerland. Predigerkirche, Zürich, Switzerland.
2003:	Galerie Sapone, Nice, France. Cathédrale Notre Dame de Paris, France. Musée de Dax, France. Festival d'Angers, France. Editions du Cerf, Paris, France.
2004:	Galerie Guy Pieters, Belgium. Galerie Yoshii, Paris and Tokyo, France and Japan. ChoSun Ilbo Museum, Seoul, Korea.
2005:	Cathédrale de Chartres, France. Cathédrale d'Amiens, France. Cathédrale de Metz, France. Cathédrale d'Evry, France. Galerie Yoshii, Paris, France. Galerie Chave, Vence, France.
2006:	Galerie Yoshii, Tokyo, Japan. Centre d'Art contemporain de l'Abbaye de Trizay, France.

2007:	Cathédrale Gand, Belgium. Cathédrale d'Albi avec le Musée Toulouse-Lautrec, France. Musée Chosun Ilbo, Seoul, Korea. Centre d'Art Contemporain d'Issoire, France. Pablo Picasso, Manfredo Borsi, Kim En Joong, Italy. Centre Umanistico Incontri Internazionali Antonio E. Aika, Italy. Editions du Cerf, Paris, France.
2008:	Galerie Yoshii, Paris, France. Galerie Cazeau-Béraudière, Paris, France. Editions du Cerf, Kim En Joong, Henri Michaux, Paris, France.
2009:	Galerie Chave, Kim En Joong - Henri Michaux, «Noir et blanc», Vence, France. Cathédrale Saint-Gatien «Les Béatitudes», Tours, France. Abbaye de Fontfroide, Narbonne, France. Centre International du Vitrail «Entre ciel et terre», Chartres, France.
2010:	Cathédrale Notre Dame de Rouen, France. Galerie Yoshii, Paris, France. Cathédrale Notre-Dame de Chartres, France. Cathédrale Saint-Jean de Lyon «Lumières de Lyon, Hommage à Saint-Irénée», Lyon, France.

	Hommage au Cardinal Godfried Danneels, Tulle, France.
	Passage Sainte-Croix «Kim En Joong, Passeur de Lumière», Nantes, France.
2011:	Cathédrale Pol-Aurélien, à Saint-Pol-de-Léon, France.
	Exposition «Le peintre de l'indicible et de l'invisible», Luxembourg.
	Musée de l'Evêché «Kim En Joong, Chantre de la lumière», Sion, Belgium.
2012:	Galerie Yoshii, « Hommage au RP. Albert Patfoort, pour ses 100 ans», Paris, France.
	Collégiale Notre-Dame de Huy, «La lumière apprivoisée», Belgium.
	Cathédrale Saint-Etienne Bourges, «Peintures-Céramiques», France.
	Hôtel Lallemant «Vitraux», Bourges, France.
	Chapelle du Bourg, «Une peinture en habit de lumière», Benboc'h, France.
	Trois lieux, trois expositions : «Un chemin de lumière»
	- Couvent de l'Annonciation, «Hommage à la Communion des Saints», Paris, France.
	- Eglise Notre-Dame des Champs, «Hommage aux douze apôtres», Paris, France.
	- Eglise Saint-Eloi, «Hommages aux béatitudes», Paris, France.

2013:	Auvers-sur -Oise, «Hommage à Vincent Van Gogh», France. Mairie de Mably (Loire), «Vitraux, Peintures, Céramiques», France.
2014:	Cathédrale de Naumburg (Saale), Germany. Galerie Yoshii «Célébration de Bibémus», Paris, France. Centre International du Vitrail : «Les peintres et le Vitrail (2000–2005)», Chartres, France. Donation d'œuvres du Père Kim En Joong à la ville d'Issoire, Espace Jean-Prouvé, tableaux, céramiques (Auvergne) France.
2015:	Cathédrale Saint-Pierre de Beauvais, peintures, Beauvais, France. Galerie Chave «Lumière», peintures, livres illustrés, estampes, Vence, France.
2017:	Urbaniana, Rome
2018:	O Lumen, Madrid
STAINED-GLASS WINDOWS MADE IN EUROPE	1973 Eglise des Dominicains, Fribourg, Switzerland. 1989 Eglise Saint-Jean-Baptiste, Angoulême, France. 1998 - 1999 Cathédrale de la Résurrection, Evry, France. 1998 Monastery of Saint-Catherine of Siena, chapel, Drogheda, Ireland. 1999 Dominican Convent, chapel, Belfast, Ireland. 2000 Santa-Sabina Convent, chapel, Rome, Italy. 2000 & 2002 Eglise Sainte-Brigitte, Perguet, Francia.

	2001 Monastère Saint-Dominique, chapel, Dax, France.
	2002 Dominican Catholic Mission, oratory, Zurich, Switzerland.
	2002 Church of Graignamanach, Ireland.
	2002 Quinn School of Business, meditation hall, Dublin, Ireland.
	2003 Parish church, Saint-Gerold, Austria.
	2005 Parish church, Craintilleux, France.
	2005 Eglise Saint-Joseph-Artisan, Paris 10ème, France.
	2005 Monastère de Ganagobie, chapel, Ganagobie, France.
	2006 Cathédrale Notre-Dame, crypt, Chartres, France.
	2006 Château de Cauneille, chapel, Cauneille, France.
	2006 Holy Trinity Church, Daejon, Korea.
	2006 Parish church, Thorigné-d'Anjou, France.
	2006 Institut Montalembert, chapel, Nogent-sur-Marne, France.
	2007 - 2008 Couvent des Franciscaines, chapel, Paris 17ème, France.
	2007 - 2009 Basilique Saint-Julien, Brioude, France.
	2007 Couvent des Dominicaines, chapel, Brioude, France.
	2007 Eglise de la Sainte-Trinité, Lyon, France.
	2007 Oratoire de la Sainte-Face, chapel, Tours, France.
	2008 Eglise Saint-Patrick, Saint-Erc oratory, Slane, Ireland.
	2008 Eglise Saint-Pierre-et-Saint-Paul, Montceaux-l'Etoile, France.
	2009 Abbaye de Fontfroide, chapelle des Morts, Narbonne, France.

2009 Collégiale Saint-Thiébaut, Thann, France.

2010 Couvent des Dominicains, Nouvain-La-Neuve, Belgium.

2011 Couvent des Soeurs domicaines, Ambert, France.

2013 Cathédrale Saint-Paul de Liège, Belgium.

2013 Chapelle du Couvent des Sœurs de Marie Réparatrice, Tamatave, Madagascar.

2013 Chapelle du Kreisker, Saint-Pol-de Léon (Finistère Nord), France.

2013 Eglise Saint-Martial d'Orgnac-sur-Vézère (Corrèze) France.

2013 Eglise Saint-Pierre Saint-Paul, Diennes Aubigny (Bourgogne), France.

2013 Mairie de Mably (Loire), France.

2013 Stained-glass at the Editions du Cerf, Paris 13ème, France.

2014 Chapelle de la Bâtiaz, Martigny, Switzerland.

2014 Chapelle Saint-Dominique, Institut Montalembert, Nogent sur Marne, France.

2014 Eglise Saint-Martin d'Ajat (Périgord Noir), France.

2014 Eglise Saint-Remi/Saint-Léon, Maisons-Alfort, France.

2015 Congrégation des Lazaristes, Maison Antoine Portail, Paris 6ème, France.

2015 Saint Mel's Cathedral, Longford, Ireland.

Artistic Work

As mentioned, Kim En Joong has developed his talent in many different fields, namely painting, lithography, stained-glass, ceramics, apparel . . . However, in light of the objective of this study, in the following pages we will focus exclusively on his pictorial productions.

In this domain, our artist has produced countless works. Nearly none of these has a title. Admittedly, this choice creates a difficulty: how can one refer to a specific work of art?

But Pe Kim has acquired this habit to avoid conditioning the spectator with any figurative reference, thus enabling whoever contemplates the artwork to situate himself in front of it in a state of complete openness towards what the painting may transmit. As a result, the identity of each individual painting stands out, yet simultaneously one can strongly sense how each one of them belongs to an ensemble, which the artist calls his 'pictorial universe'. In the case at study, we will be approaching the entirety of Pe Kim's paintings from the standpoint of the unifying message which it conveys.

This description of Pe Kim's choice can serve as an introduction:

> Brother Kim has chosen to express himself through abstract ideas which, in itself, is nothing new. On the contrary, it has aroused the passions of numerous enthusiasts of a religious art that is however saturated with images. It is not for the sake of ease that the artist has opted for the informal. Fundamental and imperious, his quest for the lost Paradise cannot be satisfied by sacrosanct reproductions of a catalogued truth.[1]

1. Kim En Joong, *Bruxelles-Paris, Expositions du jubilé de l'an 2000* (Paris: Cerf, 2000), 16.

Abstraction

The first thing that needs to be said is that we are dealing with abstract work. Though this aspect is the most obvious, it can also be one of the most surprising; it is unusual for a non-figurative painting to achieve success in the ecclesiastic world. Indeed, the latter is deeply anchored in and burdened by figuration, due to the rupture which exists nowadays between the ecclesiastic and the artistic languages, and to that which we have discussed previously. When it comes to religious matters, what is the meaning of abstraction? As Jean-Louis Prat says: 'Presently, for nearly a century, non-representation—abstraction?— can suitably fill a work of art and substitute itself to any excessively sacralised figure.'[2]

To address these matters we need to start recalling that painting, just like any art, is mimesis, in the canonical sense of re-creation of nature, in accordance with the various forms in which it presents itself; or, if we wish to express this in a more modern way, as an act representing reality in the language of communication. Thus the main question resides in the relationship between the artist and the object of his representation; and this relationship is always conditioned by culture.

Modern culture presents an incurable imbalance on this issue. Our relationships to the world are governed by our intelligence via its mental coordinates; the materials of knowledge must be woven into this fabric of conceptual categories. Everything that cannot be reduced to the system is expelled and remains flowing through the universe of the unknowable, a world which is strange—when not hostile—for our intelligence, and therefore it settles in a limbo which is only accessible to the subjective uncertainty of perception.

On a further level rules the formalised linguistic system through which the 'understanding' of things becomes possible. Is understandable only what is expressible—some people state that thoughts themselves are constructed with linguistic tools, especially with codes of the spoken language—and that what language cannot express, for lack of tools or structures, is defined as incompatible with intelli-

2. Désormais, depuis près d'un siècle, la non-représentation—l'abstraction?—peut idéalement emplir une œuvre et se substituer à toute forme trop sacralisée. Jean-Louis Prat, Directeur de la *Fondation Maeght* en Kim En Joong, *Kim En Joong: Paris-Tokyo-Séoul 2004* (Paris: Cerf, Paris 2004), 6.

gence and, therefore, is placed outside this world. But if language can express the world, it is because it reorganises and denatures it according to its own norms. Nevertheless, this convention is what guarantees communication between speakers.

This double filter, the warp of intelligence with the inescapability of its procedures on one hand, and the parcel of language with the rigidity of its codes on the other, constitutes the cultural system that has developed throughout history, and that is at the same time the condition and the limit of the relationship between man and the objects that relate to him. Thus, it is a prerequisite for any type of focus, it defines the orientation of all knowledge, the link to any opinion. In fact, it is a true prejudice.[3]

All this is very 'Western' and very 'scientific', linked to a logic of opposites which leaves no space for grey zones and relinquishes what does not fit into it, such as the sense of the divine, the consistency of silence, the intensity of contemplation . . .

Since the beginning of modern times, Western culture has carried on slowly closing the curtain of the sky, hiding always more the existence of the invisible world. From then on, all attention has been placed on progress, on what can be verified empirically, on what is rational, efficient, and quantifiable. Man has lost his sense of generosity, his hospitality, his ability to think for himself, and a great part of his contemplative attitude. As a consequence, he now has a black spot on his retina and can barely, on occasion, perceive the invisible and the world of mystery.

This is the 'concept' that prevails nowadays: clear, precise, unambiguous; that which needs not to be explained; that which shows but does not suggest; that which is unable to grasp the rich contents of what is beyond us, that is our inner, invisible world, God. This down-to-earth guideline is essential in philosophy, but in theology it is not the best suited to explore the field of religious, transcendental matters; it does not provide us with an appropriate language to express Man and God as deeply as can be.[4]

The impressionists had already become aware of this mentality, so topical in our times, and later also Picasso, the futurists, Mondrian . . .

3. On this subject you may refer to Flavio Quarantotto, in Kim En Joong, *Opere recenti* (Bellona: Centro umanistico incontri internazionali, 2001), 9–11.

4. *Cf* Cardinal Godfried Danneels, in Kim En Joong, *Kim En Joong: Rouen-Paris-Mechelen* (Paris: Cerf, 2010), 2.

who used science itself to elude such restrictions, to avoid prejudice. In this European development of integration, Eastern inspiration played an important role.

Kim En Joong's path also follows these lines; having studied in Europe as an adult, he is a Catholic, a Dominican, but his cultural premises and roots are Korean.

'Today's world, ever more materialistic, has become too heavy to be able to elevate itself; it owns everything but it has forgot that Man's fate is Exodus.'[5] Having renounced the polarisation of knowledge around science, a concept developed by positivism and its variations in the West, the Far East has kept a simple relationship to nature, accepting other methods of acquiring knowledge, thus similar in many ways to the European attitude during the Renaissance.

Its axiom is that man is part of nature and nothing in it is foreign to him. Thus everything can enter into a relationship with everything. Intelligence and perception are not opposite but contiguous, as they are interactive ways to relate to things. The act of writing itself, beyond merely codifying sounds according to the rules of the alphabet, translates objects iconographically, and thus accepts the ability to interpret things characteristic of those who are not confronted with the key but rather with the image of things reduced to their essence.

The distance between painting and writing, between their various codes but especially between the preambles that constitute their respective roots, can be radically summarized. The picture bears the echo of the sound, knowledge maintains the visual, phonic, and architectonic parameters generated by objects. United once again, these codes preserve in writing the emotional characteristics of whoever took the object's essence and transposed it—by means of a paintbrush—into written words.

Under these circumstances, language emerges from things, both are similar and consubstantial. Nonetheless, it is unnecessary to force them into codified classifications. Everything is expressible and thus belongs to man's world.

Kim En Joong starts from here, from this notion of language.

5. 'Le monde actuel de plus en plus matérialiste est devenu trop lourd pour pouvoir prendre de l'élévation, il a tout obtenu mais il a oublié que le destin de l'homme est l'Exode.' Kim En Joong, *Bruxelles-Paris, Expositions*, 8.

In the positivist culture, colour is an accident, a secondary quality of the object; its properties are functions of the light and way in which it is spread and reflected. In the culture that served as Pe Kim's point of reference, substance and accident do not oppose each other; on the contrary, both contribute to defining a portion of infinite nature. Colour is inside things and perhaps, since substance is unique and all things are part of it, colour might be the distinguishing element of all things. Therefore, it has dimensions and temperatures, movements and orientations, thickness and lightness, transparency and extension. It is key to understanding the universe. In this world, nothing is excluded because the filters enabling its comprehension have not been imposed on nature by man. The Logos imbues people and things; it animates everything, as does the wisdom that puts order into the universe, and this order reveals the harmony of a design which encompasses the entire creation and justifies it.

While Catholicism unites East and West, art is an effort to understand and, at the same time, to identify oneself with the great scheme. The artistic practice has an ethical, maybe even an eschatological dimension. It certainly is an act that purifies and calms in joy.

> Here, where art and science coincide at last, ethics and aesthetics become one, and as a whole they require the rigour of an inexhaustible investigation that seeks to capture the intuition of the absolute and to refine the instruments of writing to an incredible extent, until they become appropriate to achieve the expansion of our vision.
>
> These are the tools that have freed things of all load, to leave them only with what does not change, meaning the light that goes through bodies and makes them diaphanous and individually tangible, even behind the impalpable veil of colour.
>
> These are the tools that, in the broad array of colours at the service of this art, have introduced the wisdom of an architectonic balance that is so intellectually refined that we can only find rare examples thereof in the West, for instance perhaps in the *Quattrocento*.[6]

6. 'Qui, dove arte e scienza finalmente coincidono, etica ed estetica sono una sola cosa ed insieme esigono il rigore di una ricerca inesausta puntata ad afferrare l'intuizione dell'assoluto ed a raffinare, fino all'incredibile, gli strumenti di scrittura

Thus, the works of the Dominican entail a 'reading' time, requiring the spectator to follow a path. The starting point can be the jump of some colour to the foreground, or the line that contrasts with a prevailing clutter of hues and colours. Here begins the journey which, following shapes one after the other, directs our gaze towards an ever-distant centre where the mind progressively strays, drawing infinity, or expands into a centrifugal spiral that encompasses an expanding universe. It is an itinerary that takes the observer to a dimension which he had not yet experienced. On this path, space and time overlap, fuse together, and come to a close, like in a sphere that keeps concentrating 'until it explodes and there, in a final' burst of light, emerges the immense meaning of eternity.

'Kim En Joong's work is, in this sense, an announcement of the Theophany'.[7]

As a manifestation of the invisible, as a dialog, Pe Kim's work implies a great dynamism and necessarily entails renewal. The artist himself defines the constant novelty of his work when he explains why, for some of his paintings, he chose a format in the shape of a fan:

> My pictorial universe, this time, falls within the shape of a fan: thus it is transformed, like a man who changes his outfit. A fan captures the world very differently than do a square, a circle or a triangle.

> A fan will make me dream. It will take me to a land of legends. For me, it is not a mere semi-circle or a half-moon: it is the setting sun dipping behind a cloud, a mountain overlooking a lake, or a ray of light reflected upon the water.

> Because of its elegance, the way it unfolds, a fan takes on a meaning that is unique to this shape.

per renderli idonei a rendere la rarefazione della visione. Sono gli strumenti che hanno tolto alle cose ogni gravame, per lasciare loro solo ciò che non muta, la luce, cioè, che attraversa i corpi e li fa diafani ed insieme individualmente tangibili pur nell'impalpabile velatura del colore. Sono gli strumenti che nella estesissima gamma cromatica a servizio di quest' arte hanno introdotto la sapienza di un equilibrio architettonico di una tale raffinatezza intellettuale—questa si—che in occidente ha esempi, rari, forse nel Quattrocento.' K En Joong, *Opere recenti*, 10.

7. 'L'opera di Kim En Joong è annuncio di Teofania.' Kim En Joong, *Opere recenti*, 10.

And if one unfolds it? Like a hand opening its fingers, it becomes an offering. The offering of a vision hidden until then.

Art must also unfurl into other forms to renew itself. Tradition is only valid if it is constantly renewed. I am opening my windows. I want to change the air of my universe to find another world.[8]

Just like love, as it occurs with Revelation, knowledge continuously goes through processes of creation and re-creation; these are relationships that can be understood as journeys, as discoveries, and never as stagnant impositions.[9]

So the artist's intention connects with the same Revelation, which St Thomas Aquinas had already understood as movement: 'Hence, among men, the knowledge of faith had to proceed from imperfection to perfection.'[10] Or else: 'Man is not associated with these teachings suddenly, but rather in a progressive way, according to the module of his nature.'[11]

For this reason, movement is equally confined in all his paintings. The colours, lines and shapes are disposed in such a way that they mysteriously transport us to a tridimensional world, withdrawing and interacting, flowing across the canvas. Each painting gently transports the spectator in his own inner dynamism, guiding him by

8. 'Mon univers pictural, cette fois, s'inscrit dans la forme de l'éventail: il en est transformé, comme est transformé un homme qui change de costume. Un éventail saisit l'univers tout autrement que le carré, le cercle ou le triangle. L'éventail me fait rêver. Je m'y promène dans un pays de légendes. À mes yeux, il n'est simple demi-cercle ni demi-lune: il est soleil couchant qui s'enfonce derrière un nuage, montagne surplombant un lac, ou rayon de lumière allongé sur les eaux. Par son élégance, par son déploiement, l'éventail prend une tout autre signification que les autres formats. Le déplie-t-on? Telle une main dont les doigts s'ouvrent, il devient offrande. Offrande d'une vision jusque-là cachée. L'art, lui aussi, doit se déployer en d'autres formes pour se renouveler. La tradition n'est valable que sans cesse renouvelée. J'ouvre mes fenêtres. Je veux changer l'air de mon univers pour retrouver un autre monde.' Kim En Joong in AA.VV, *Kim En Joong,* 29.

9. M Gelabert, *La Revelación, acontecimiento con sentido* (Madrid: San Pío X, 1995), 58.

10. *ST,* II-II, q.1, a. 7, ad 3.

11. *ST,* II-II, q.2, a3c.

means of its sinuosity, the cadence of its brushstroke, its chromatic intensity, and subtly, it elevates him above his own reality.

This process is present on all levels, including in the making of the work since our artist usually paints while standing, bowed over a canvas which he has stretched out on the floor, walking around it, up and down, answering a call that the painting itself, as it is emerging, sends out to him from each of its corners.

Preliminary Preparation

'Kim En Joong paints standing up, leaning towards his canvas extended on the ground. Painting, meditation, and energy thus go hand in hand. Paintbrush, brushstroke, scraping off . . .'[12] For that reason, before he starts working, the artist undergoes a physical preparation—he exercises and stretches his muscles—but also a spiritual one. He breathes shallow and concentrates, he needs a serene environment where he can pray, contemplate, disconnect from his mundane concerns and worries, so that he can clearly perceive what he is about to capture. For the Dominican artist, the creative process, the act of painting itself is like a prayer: it is another way of connecting with God. That is how he presents it to his friends and relatives:

> Though he does add a prayer to my intention in his correspondence, it remains true that what separates us, meaning religion, results in our exchanges being more oriented towards art; nonetheless, he has admitted to me that the act of painting is for him no more than a means of communication with God: it does not on its own suffice to fill his entire life.[13]

This act reflects another key phrase of the Dominican Order—*to praise, to bless, to preach*. Pe Kim explains in more detail what painting feels like: 'All too often I choose colours as I might choose a fish to

12. Kim En Joong, *Bruxelles-Paris*, 16.
13. 'S'il est vrai qu'il accompagne ses correspondances d'une prière pour ma personne, il n'en demeure pas moins que ce qui nous sépare, à savoir la religion, fait que nos échanges sont plus orientés vers le domaine artistique: il m'a pourtant avoué que pour lui, l'acte de peindre n'était qu'un moyen de communication avec Dieu: il n'est pas en lui-même la totalité de sa vie.' Kim En Joong, *Kim En Joong: Rouen*, 4.

put in an aquarium, or a good wine to decant. For me, art is an act of adoration, a submission to beauty and an act of love.'[14]

The process of initial preparation is so important for Pe Kim that, if something fails, if he feels tired or upset, or senses that he is not fully in control, he prefers not to start at all and to postpone work until a better moment:

> We do not ask how he hatches his plastic revolution, which 'recipe' he uses. We prefer to dwell on the immersion of the artist in his work. In effect, it is total. 'To begin with, I feel a bit like a boxer going into the ring. I have to master the canvas for a long time . . . To stand a chance of managing that, I have to be in some kind of state of grace. If I doubt or I feel tired, it's better to put it off to the next day!'[15]

These habits leading up to the act of painting are very important, in part because they match the Dominican way of proceeding before preaching: as dictated by the previously cited motto of the Order of Preachers (known as the Dominicans), one must contemplate in order to give what is contemplated. The artist himself explains it with these words:

> Before I tackle a big white canvas, I close my eyes. I evoke the image of a blue sky where stars are emerging. My hands accompany wings as they take off.
>
> Beyond any mundane imagery, a new sight emerges, lines and colours appear on the canvas. The outside darkness backs off while the bright interior imposes itself little by little—mysteriously. The movement and its statism reflect the pulsation of inner life: action / contemplation.[16]

14. AA.VV, *Kim En Joong, 80ème Anniversaire du Journal Chosun Ilbo* (Seoul: Yeobaek, 2000), 82.

15. Kim En Joong, *Bruxelles-Paris,* 16.

16. 'Avant de m'attaquer à une grande toile vierge je ferme les yeux. J'évoque l'image d'un ciel bleu où apparaissent les astres. Mes mains accompagnent les ailes qui y prennent leur envol. Détaché de toute imagerie mondaine, la nouvelle fête apparaît, des lignes et des couleurs sur la toile. Les ténèbres extérieures s'éloignent tandis que, lumineux, l'intérieur s'impose peu à peu - mystérieusement. Le mouvement et son arrêt reflètent la pulsation de la vie intérieure : action/ contemplation.' Kim En Joong, *Bruxelles-Paris,* 7.

From the conjunction of contemplation and painting, Kim achieves this chromatic communion that characterises him, where each stroke dresses in colour and each colour becomes a drawing. The painter says: 'Line and colour need to be in harmony like body and soul; neglecting one or the other is not very Christian. I truly have learned this wisdom.'[17]

Pictorial Elements

The colour white, with all its connotations of purity, nakedness, and emptiness, predominates in most of his works. It is the starting point, a space in which, in theory, nothing happens. From here strokes of colour emerge, a calligraphic line provocatively progressing without hesitations or retouches and, from this decisive movement, shapes and multi-coloured blotches appear, extending throughout the entire space. Seemingly complicated, these movements, these tumultuous swirls spring forth like sources of life animating the colour, while the colour dresses the line, adorns it, disguises, defines, and defends it:

> It is colour rather than the line which draws the paper out of its lethargy, making dreams surge forth. Born of the light in which they dwell, colours, through an eternal renewal, flow into it to be nourished, and to create forces that entice matter and attract man's gaze.
>
> On the paper, colour brings scope and relief, spreading out, violently exuberant or profoundly arcane.[18]

All hues, of all intensities, are involved in Pe Kim En Joong's work, but primary colours are definitely the ones that play the main part on his palette. The basic principle of the theory of colour is that there are three colours that cannot be made by mixing others together. They are called primary colours: blue, yellow, and red. By combining these three colours in various ways, one can make all the others.

17. Personal testimony of the artist in the documentary *Lumières et couleurs* (*Lights and colours*), https://www.youtube.com/watch?v=ap66sWDvzrI&feature=yout ube, min. 2:35.
18. J Thuillier, Kim En Joong, *Rêves de Couleurs*, (Vence: Editions Pierre Chave, 1992), 33.

Because there are three, and because they 'pre-existed' before any other colour and lay at the origin of the rest, Pe Kim En Joong establishes a correlation between them and the Holy Trinity. This comparison gains depth when each of these colours reveals its own meanings and emotional values.

Thus, red is the colour of blood, it speaks of life and human matters: dedication, passion, courage . . . It refers us to the love which is God (the Father), to the incarnation of the Son and the blood he shed, as well as to the dynamism of the Holy Spirit.

It is very interesting to note that this colour, which our artist associates particularly with the Spirit, appears in nearly all of his paintings, including in those containing a large array of greys. Even though it might be in the form of a thin line, we can always spot the colour red as the expression of the Spirit who inspires and breathes life into everything.

Yellow, on another hand, evokes the Sun, and thereby light, fullness, and heat. It represents divinity, transcendence, the origin of life that is the Father, the 'light of the world', the joy of the Good News, and the fire of the Holy Spirit.

Lastly, the blue of the sky and of the sea conveys calm and purity. It speaks to us of the infinity of the Father, the peace of the Son, or the immateriality of the Spirit.

All the above also recall Mary, who represents the new humanity, who obeys the will of God, follows Christ, and is inspired by the Holy Spirit.

Our artist uses these primary colours and plays with them in such a way that they suggest relationships between the three different entities, united in the mystery of love. He unifies them in dignity, strengthens their identities, and erases their inequalities. He binds them and yet distinguishes them.

When we truly love, we feel reinforced and more secure within ourselves, and at the same time, we find ourselves so united to our loved one that the 'I' fades into a 'we' . . . These two feelings go hand in hand, each one leading to (and flowing from) the other. This experience, so human and so divine at the same time, is masterfully expressed by Pe Kim's chromatic games, with the will that it might serve us to discern the mystery of God, to grasp the feeling of being completely one and many at the same time, to place us in front of the immensity of this Love.

From these bonds, the artist's entire chromatic spectrum springs forth.

Bright colours used with great intensity sometimes appear emphatically opaque, other times, ethereal and transparent:

> As a colourist capable of capturing all possible shades in the spectrum, he makes oils sing with touches of watercolours. And his paintings as a whole somewhat resemble this long river, not as calm as that, all the colours and sentiments of a floating flower awaken us to . . .[19]

But luminosity is constant, light is omnipresent, vibrant yet never violent or blinding, whether it emanates directly from the painting or powerfully traverses it. Light is the main character of all of Pe Kim En Joong's artistic creations. This is why the Dominican artist is known not only as 'the white painter' but also as 'the artist of light': 'I cannot easily enter the universe of the man known in Korea as "the priest of light", yet once I am there, I find colour, light, purity: in front of his creations, my heart becomes calm and lights up.'[20]

With regard to composition, no symmetry is to be found in his works. Splashes of colour extend, wandering into all directions as if on some excited search. Any disturbing astonishment eventually dissolves in the depths of one's subconscious. Such structural irregularity sometimes awakens a curious interest, or on most occasions it conveys clear serenity, but it rarely instils a sense of imbalance or unsustainability. This effect might be the result of the harmony which Pe Kim En Joong confers to his art. All the elements relate to each other in a nearly musical way, as if they were part of a great symphony:

> His paintings sing like hymns. Profound, powerful and secret rhythms. Line and inspiration. An initiatory voyage swollen with musical lines and resounding beaches. And these tasks, these obstructions, these volumes, these rivers of colour, what are they if not instants of immersion in the absolute of the being that devotes itself and pours itself forth?![21]

19. Kim En Joong, *Bruxelles-Paris*, 18.
20. 'Connu en Corée comme «prêtre de la lumière», je trouve moi-même dans son univers, même si je n'y entre pas facilement, couleur, lumière, pureté: face à ses créations, mon cœur s'apaise et s'éclaire.' Kim En Joong, *Kim En Joong: Rouen*, 4.
21. Kim En Joong, *Bruxelles-Paris*, 17.

With regard to materials, Pe Kim En Joong started painting with acrylic, but this choice was made, as mentioned earlier, because of his lack of funds rather than out of true appreciation for this technique. In fact, the artist gave up water-based paint as soon as possible, considering it bleak and unrefined. Thus, from 1982 to the present, he painted exclusively with oil: 'This same year Kim abandoned "dismal and vulgar" acrylic in order to take up oils again, at the cost of much intensive work.'[22]

Water was replaced by oil, paintbrushes by spatulas, and paper by canvas. But in spite of all this, his works kept showing the same transparency and effects as his acrylics.

It is fascinating to see how Pe Kim En Joong fully concentrates on his painting, as if he were saving something from the void, something hiding in the white canvas, that he alone can see. A process in which mind and heart walk hand in hand:

> 'The design is what is felt; the colour is the reasoning', Bonnard strongly asserts. Painting needs those two elements, as a human being needs the combination of body and soul. Without this there is disorder, offering a menacing spectacle like that created by an automobile accident.[23]

Pe Kim En Joong walks around his creation, as if he were searching for ways to light it up; he stops, thinks again, bends forward, and in these moments, we get the feeling that everything flows on its own, naturally. The artist's hands spread paint, draw lines of colour, scrape them, splash them . . . Sometimes he carries out his work in a continuous way along the canvas, working on different sectors to then resume contemplation and continue searching.

> Bonnard was independent of any artistic movement. He kept clear of the dryness of Cubism. I, too, follow my solitary path, far from the attractions of a mechanical art. I marvel much more at the warmth of a hand at work than at the practice of a technique. Spontaneity of movement liberates—as does the truth; Liberty and Truth, in fact, have the same source.[24]

22. AA.VV, *Kim En Joong*, 25.
23. AA.VV, *Kim En Joong, 80ème Anniversaire*, 90.
24. *Kim En Joong, 80ème Anniversaire*, 93.

Influences

In all his public appearances, in his books, Kim En Joong proves to be a lover of art and a good connoisseur of the philosophies that have inspired various pictorial movements and styles. Perhaps this is why his art springs forth from numerous artistic sources and is the result of the conjunction of many wise influences.

In addition to the influences mentioned previously, art critics have detected a few more in the artist:

> Nurtured on a diet of both Eastern and Western arts and acknowledging that which he owes, in his early days, to Vermeer, Rembrandt and Bonnard, and also that which he owes to French Roman and Gothic art, for as long as his painting reflects them, Kim En Joong cannot silence the attraction that fluidity and movement hold for him.[25]

Along these lines, author Roger Pierre Turine picks up the influence of Eastern art, its essence and spirituality, the calligraphic drawing which Pe Kim learned from his father, as well as the bedazzlement triggered in the young man, recently arrived in Europe, by the works of the great masters of Western painting combined with the main figures of the Dutch Golden Age. Century-old styles, such as the Romanesque style, or other more recent ones such as the style of the Nabis, with Pierre Bonnard,[26] assimilated together in a reciprocal relationship reflexive of the changing and dynamic expression of the human mind.

> He is a successor of 'the Blue Rider school' who, with Kandinsky, Klee, Chagall and others, experience and express the spiritual in art and speak in a 'funny tongue', like St Theresa. Their art is beyond rationality. Kim's art can be felt and experienced, even if we cannot describe it in our ordinary language. We must resort to that second language which is used to express myths, images, dreams, visions, and revelations. Those who meditate

25. Kim En Joong, *Bruxelles-Paris*, 16.
26. Pierre Bonnard (1867–1947), a French painter who is considered the main instigator of the Nabi movement, and whose last works were precursors of abstraction in the realm of painting. He dedicated his talent to the publicity and production of art.

and contemplate and sit quietly by the sea find joy and delight and a sense of a higher realm of reality in Kim's art.[27]

John J Weaver relates Pe Kim En Joong to the group of expressionist artists who, under the name of The Blue Rider (*Der Blaue Reiter*), contributed to the importance of interiority in art. They also rescued the legacy of other, non-Western cultures, and restored the value of primitive art.

The influence of the impressionists cannot be questioned either in the artist's works. The fracture with academic conventions, the creative spontaneity, and the importance of light and colour are all elements that can also be found in Pe Kim En Joong's painting.

Having said that, the author himself acknowledges his main influences as being Matisse and Chagall,[28] as well as Degas and Cézanne.

He admires the fluency of Henri Matisse's[29] drawing, his expressivity, and his mastery in the use of colours. The influence of this artist is also obvious with regard to the search for simplicity, the freedom from detail and the harmony within each work of art.

With Marc Chagall,[30] whose work is also vibrantly colourful and expressive, Pe Kim shares the neat and intense way of manipulating colour, the optimism and positive outlook on reality, and the mystery which impregnates all his canvases and causes the spectator to come to a stop.

Regarding Degas,[31] he believes that: 'With Degas, form and composition are worthy of admiration. From them, freshness springs up. Contemporary art too often lacks elegance.'[32]

27. Kim En Joong, *Unity for peace. Grace Cathedral Exhibition* (Grace Cathedral Yeobaek/San Francisco-Seoul: Grace Cathedral, 2002), 6.

28. Personal testimony of the artist in the documentary *Lights and colours,* https://www.youtube.com/watch?v=ap66sWDvzrI&feature=youtu.be, min. 22:45.

29. Henri Matisse (1869–1954) is a French painter, recognized as a great master of twentieth century painting. He had connections to the Order of Preachers and he is the author of the famous drawing of Saint Dominic de Guzman, and of the decoration of the Dominican Rosary Chapel in Vence.

30. Marc Chagall (1887–1985) is a Belorussian painter of Jewish origin. He was connected to numerous avant-garde movements without ever identifying himself with any of them. Among his most famous works we can mention the white Crucifixion or the Virgin of the aides.

31. Edgar Degas (1834–1917), French painter and sculptor, considered as one of the fathers of Impressionism.

32. Chez Degas composition et forme sont à admirer. D´elles jaillit la fraîcheur . . . L'art actuel manque trop souvent d´élégance. AA.VV, *Kim En Joong, 80eme Anniversaire,* 88.

And in Paul Cézanne's[33] efforts to simplify shapes by means of planes of colour, Pe Kim finds the doorway to abstraction.

This review of his influences cannot be concluded without mentioning the man who, as a Dominican artist, is his greatest mentor: Fra Angelico. Pe Kim En Joong is said to have written a letter to the Blessed brother in which, after acknowledging his predecessor's mastery, he expresses feeling sincerely close to him and in the continuity of his mission:

> Dear blessed Fra Angelico:
> Beyond the centuries and in spite of the cultural difference which separates us, we share a common vision: that of the Splendour of Beauty.
>
> You had a surreal vision. You expressed yourself as a fifteenth century painter . . . I feel no breach between you and me, but a continuity. Your pictorial purity may very well come rest on my canvas. Your reds and blue-yellows also express joy for you (. . .)
>
> You have taught me the ontological vision. But I do not want to remain in an angelic 'softness'. With a violent purifying stream I would like to whiten this polluted world . . . I have chosen non-figurative expression. I am groping around to bring together an orchestra of colours and forms, just as one gropes around towards Paradise.[34]

33. Paul Cezanne (1839–1906) French postimpressionistic painter. His paintings laid the foundations of the evolution of art from the understanding of the nineteenth century to the conception of the new century, which is why he is considered the father of modern painting.

34. 'Cher Bienheureux Fra Angelico: Au-delà des siècles et malgré la différence de culture qui nous sépare, nous avons en commun une même vision: celle de la Splendeur de la Beauté. Vous aviez une vision surréaliste. Vous vous êtes exprimé en peintre du XVe . . . Je ne sens aucune rupture entre vous et moi, mais une continuité. Votre pureté picturale peut fort bien se poser sur ma toile blanche. Vos rouges et vos bleus-jaunes traduisent aussi pour vous la joie (. . .) Vous m'avez appris la vision ontologique. Mais je ne veux pas rester dans la 'suavité' angélique. D'un jet violent purificateur, j'aimerais blanchir ce monde pollué . . . J'ai choisi l'expression non figurative. Je réunis un orchestre de couleurs et de formes en tâtonnant, comme on va à tâtons vers le Paradis.' J Thulier, *Kim En Joong, Peintre de*, 169.

Although one could say that Kim En Joong's work collects elements from nearly all styles and trends of the history of art, the artist integrates them in his pictorial universe in such a way that the result is different from anything seen before, something unique and personal.

On a theological and spiritual level, his work naturally stems from the Dominican tradition. We have already referred on various occasions to the way in which the artist conceives his work as a search for Truth, and as praise, blessing, and preaching that wells up from him who contemplates.

This is a conviction that St Catherine of Siena had already expressed as follows: 'Everything that is done by word or action for the health of the souls is virtually a prayer.'[35]

Similarly, the theology of St Thomas Aquinas is also present throughout his entire creative process, as he says himself:

> All of these works complete each other. It is not their aim to provoke demands for explanations. They are, rather, an invitation to discover a hidden world. A world of clarity, of proportion and integrity, in accord with St Thomas Aquinas's 'Treatise on Beauty'.

> 'Clarity, proportion, integrity', three words which will be my guides for the future. It is my wish that my work would be like a small star in the firmament, rather than an artificial light which hurts the eyes.[36]

These conditions suggested by Aquinas to define beauty, as an expression of human fulfillment, are references which orient the artist in all his paintings.

However, the Dominican influence does not stop here: the rich tradition of the Order is also present in the mysticism and spirituality which flood Pe Kim En Joong's work, from its making to its exhibition to the public.

In the forefront, his search which, by means of abstraction, transcends the material world and its natural phenomena to point towards the essence of nature itself, towards the absolute, puts us in relation with Master Eckhart's spirituality:

35. AA.VV, *Doctrine of Catherine of Siena* (Puebla: Archdiocese of Puebla, 1980, c.310), 19.
36. AA.VV, *Kim En Joong, 80ème Anniversaire*, 8.

There was a Rhenish Dominican, Johannes Eckhart, known as Master Eckhart, theologian and philosopher who taught in Paris and Cologne at the end of the eighteenth century, who spoke for many contemporary abstract painters when he said:

'In order to discover nature in oneself, one must reject all subterfuges, all false images'.[37]

Thus, when our artist describes and explains his vision of art as an endless search for God, of the creative act as an intimate union with Him in everything, it is easy to detect once again the trace of the Rhenish mystics' school of thought:

> Because he has God, his intention flows only towards God and for him all things change into nothing but God. This man carries God in all his works and in all places; and all the works of this man are only made by God. Because the work belongs more rightfully to him who causes it than to him who produces it.'[38]

We can also recognise the spirituality of Taulero and Suso in Pe Kim En Joongs's need for emptiness before he can start painting, in his way of ridding his work of all superfluity via a process of 'purification'[39] which proves to be difficult, sometimes even requires suffering, but which ultimately leads to other stages of 'illumination' and, finally, to the 'union' with God which is expressed on the canvas: '"Suffering is a brief pain; having suffered is a long-lasting joy", said Henry Suso. May this long-lasting joy be the artist's reward'[40]

In the documentary *Lumières et couleurs* (Lights and colours), the artist speaks of this suffering, sometimes caused by the creative process when it escapes his control, as well as of the feeling of 'puri-

37. 'C'est un dominicain rhénan, Johannes Eckhart, dit Maitre Eckhart, théologien et philosophe enseignant à Paris et à Cologne à la fin du XIIIe siècle, qui a parlé pour de nombreux peintres abstraits actuels lorsqu'il a dit: "Pour découvrir la nature en soi, il faut rejeter tous les faux-semblants, les fausses images". J Thulier, *Kim En Joong, Peintre de*, 215.

38. M Eckhart, *Spiritual instructions*, in Jeanne Ancelet-Hustache , *Maître Eckhart et la Mystique rhénane* (Madrid: Aguilar, Madrid, 1962), 88.

39. P Dinzelbacher, *Dictionary of Mysticism*, 948.

40. 'Souffrir est une douleur brève; avoir souffert est une longue joie », dit Henri Suso. Puisse cette longue joie être la récompense d'une vie d'artiste.' AA.VV, *Kim En Joong, 80ème Anniversaire*, 88.

fication' which overcomes him while he paints, for in this action he forgets all negative things and bad feelings, and he experiences it as an 'act of reconciliation':

> At the beginning I started with a very simple idea, but the more progress I made, the more difficult it became to control this idea. For several days I even suffered to recover it (. . .) When I paint, I forgive everyone. It is like an act of reconciliation. It's very odd. I always want to remain in a beautiful melody, such as Beethoven's 'Ode to Joy' or the 'Veni Creator', but heaps of memories assail me that I cannot control, so, in those moments, I think about the act of reconciliation. I feel purified when I burn all that is bad.[41]

Lastly, in understanding this process in its entirety, this path of contemplation and union with 'Light' which will later be captured on the canvas as a subtle preaching, we can also find an echo of Fr Arintero's words:

> And this is the great lesson which He teaches all his beloved disciples and zealous followers, who wish to be where He is and in the same manner as He is, so that, seeing his divine clarity, they might always carry the light of life and communicate it secretly to others.[42]

On another hand, we have mentioned the important contributions of the artist's brothers in religion: the thoughts of Dominican Frs Sertillanges and Couturier, with the French *Journal L'Art sacré* and its various initiatives, laid the foundations for the church of the Plateau d'Assy, for Matisse's chapel in Vence, Le Corbusier's church in Ronchamp, and Manessier's stained-glass windows in Bréseux. Those artists were open to new forms of creation: 'The decline of sacred art also has spiritual and social causes. But its artistic causes can all be brought down to academicism, either directly or indirectly.'[43]

41. Personal testimony of the artist in the documentary *Lights and colours*, https://www.youtube.com/watch?v=ap66sWDvzrI&feature=youtu.be, min. 3:07-4:55.
42. JG Arintero, *Cuestiones místicas*, p
43. La décadence des arts sacrés a aussi des causes spirituelles et sociales. Mais ses causes artistiques se ramènent toutes à l'académisme, directement ou par contrecoup. S Lavergne, *Art sacré et modernité. Les grandes années de la revue L'Art sacré* (Paris: Lessius, 1999), 29.

Yet if the open mind-set created by those Dominican priests was fundamental, so was the support and advice of some of the brothers of the community, such as Frs Lelong, Avril, and Geiger. They encouraged Pe Kim En Joong in his artistic vocation and offered him theological and spiritual arguments which enabled him to reconcile his two passions: 'How much encouragement I've received from two nonagenarians! The one said to me: "The universe extends at my feet!". The other: "Your soul is transparent like Teilhard de Chardin's meditation in front of the cosmos".'[44]

Among all the brothers, it is essential to highlight the figure of Fr Albert Patfoort OP, who was Professor of Metaphysics and Theology at the Angelicum in Rome whom Pe Kim considers as his spiritual father. Fr Albert, who died at the age of 101, was also a source of artistic inspiration for our painter, who made various portraits of him, as well as a collection of one hundred small canvases painted for him as a homage on the occasion of his hundredth birthday.[45]

The relationship he wove with his elder brother was extremely tight; the master's ability to be amazed bond him for life to Kim En Joong, even though thirty years separated the two men:[46]

> Father Kim always accompanied Father Albert Patfoort throughout his old age, and one can also say that Father Albert Patfoort never ceased to accompany Father Kim in his work and in his life. Father Albert Patfoort was the first to contemplate each new painting by the artist.[47]

44. 'Quel encouragement m'ont donné deux nonagénaires! L'une m'a dit "L'univers s'étend devant mes pieds!" L'autre "Votre âme est transparente comme la méditation de Teilhard de Chardin devant le cosmos !". AA.VV., *Kim En Joong, 80eme Anniversaire*, 87.

45. This collection was exhibited in February 2012, in the famous Yoshii Gallery in Paris.

46. Fr Nicolas JEAN-SED, in the documentary *La fragilité des choses solides (The fragility of solid things)* https://www.youtube.com/watch?v=oA-_gvML1xc, min.4.

47. Le Père Kim a toujours accompagné le Père Albert Patfoort au long de ses vieux jours, et l'on peut dire aussi que le Père Albert Patfoort n'a cessé d'accompagner le Père Kim dans son travail et sa vie. Le Père Albert Patfoort était le premier à contempler une nouvelle création de l'artiste. Fr Nicolas Jean OP in the web site of artist, http://www.kimenjoong.com/html/amitie/fiche.aspx?id=13.

During the last years of Fr Albert's life, Pe Kim En Joong took charge of looking after him personally, up to the end. The importance of this friendship and its influence on our artist's work can be sensed in the collection of 164 cards published in the book *De la terre au ciel*, by Kim En Joong at Editions du Cerf.[48]

There is no shortage either of influences proceeding from other circles beyond his own Order, from great Spanish mystics such as St Teresa of Ávila or St John of the Cross:

> 'Beauty is a search, beauty is an effort, beauty is a victory. Beauty is an impeccable achievement, an incessant opening leading to a dazzling perfection', writes Fr Sertillanges. The thirst for beauty is like that of a man lost in the desert, seeking hidden sources. When I am alone, I truly feel as if I were on the threshold of an inexpressible plenitude, inviting me to forget myself. And I no longer feel alone . . . Each canvas is for me like a piece of land needing to be worked, so that its fruit may be harvested in the autumn.[49]

If we identify beauty with the supreme beauty which is God, we can find some similarity between his experience and the one described by the St of Teresa of Ávila or by St John of the Cross in their writings.

Thus, the thirsty walk through the desert, the desperate and tireless search, refer to the *Spiritual Canticle*:

> Shepherds, you who go up
> through the sheepfolds to the hill,
> if by chance you see him I love most,
> tell him I am sick,
> I suffer, and I die.
> Seeking my Love
> I will head for the mountains and for watersides,

48. K En Joong, *De la terre au ciel* (Paris: Cerf, 2014).

49. "'La beauté est une recherche, la beauté est un effort, la beauté est une victoire. La beauté est une réalisation sans déchet, une éclosion sans point d´arrêt jusqu'à la perfection éclatante", écrit le Père Sertillanges. La soif de la beauté telle la soif d´un homme perdu dans le désert à la recherche du puits caché ! Quand je suis seul, vraiment, je me sens au seuil d'une plénitude inexprimable m´appelant à l´oubli de moi-même. Et je ne me trouve plus seul . . . Chaque toile m´est une terre à travailler pour que soit cueilli son fruit en automne.' AA.VV., *Kim En Joong*, 80ème Anniversaire, 84.

> I will not gather flowers,
> nor fear wild beasts;
> I will go beyond strong men and frontiers.[50]

Similarly, the intimate accompaniment in solitude is reflected in *Flame of Living Love*:

> How tame and loving
> Your memory rises in my breast,
> Where secretly only you live,
> And in your fragrant breathing,
> Full of goodness and grace,
> How delicately in love you make me feel![51]

The growth, the progressive discovery entailed by such an itinerary can also be found in the *Interior Castle*, where St Teresa repeats the same thesis exposed in the book *The Life of Teresa of Jesus*. In her analogy of the soul seen as a castle, one must go exploring successive chambers, and this journey culminates with the union with God: the vows (6th Mansion), which allude to the ultimate purifications and the high spirits of love in the wait for God; the spiritual marriage (7th Mansion), final state characterized by the presence of God in the life of a Christian (union) and by the apostolic fecundity of this fullness of life.[52] This spiritual marriage is not an achievement meant to lead us away from reality and our fellow men; on the contrary, it reveals itself through the fruits of its charity. Pe Kim expresses a similar message: '. . . we try to reach the union with God, not to rejoice in it ourselves, but to use this strength to serve others.'[53]

To conclude on this subject it is necessary to note the artist's special appreciation for St Francis of Assisi and his evangelical simplicity:

> The Right Reverend William E Swing wishes the exhibition to
> be conceived in an ecumenical spirit and that it should also

50. Juan de la Cruz, *Obras*, 445. The English translation is found in *The Collected Works of St. John of the Cross*, by Kieran Kavanaugh, OCD, and Otilio Rodríguez, OCD, revised edition 1991.

51. Juan de la Cruz, *Obras*, 645.

52. *Cf* E ANCILLI, 'Teresa de Jesús', *Encyclopedic dictionary of Spirituality*, 482.

53. *Cf* Tersa de Jesús, *The Mansions*, in Teresa de Jesús, *Complete works* (Madrid: BAC, 1979), 363–450.

mark an encounter between East and West. It is this openness at once to unity and to peace which excites my admiration for you, Francis of Assisi. How splendid has been your search for the sole source of true unity. In my work as an artist I have always endeavored to deploy your childlike simplicity. In true art there is only wonder.[54]

The last influence that cannot be overseen is that which stems from the meeting of two cultures, of the two worlds living inside Kim En Joong: the East and the West.

It is worth stressing here his friendship with François Cheng, a poet and writer born in China, established in France, and member of the *Académie française*. This relationship began in 2008 and resulted in various collaborations and mutual homages. Thanks to Cheng's presence in his life, our artist was able to share and rationalize his Eastern heritage, the difficulties of his transition to the West, and the harmony between the two.

The writer asserts it is possible to define two key moments in Kim's artistic evolution: his mastery of the Eastern technique of calligraphy and his constant need to express light, which he learned in the West.[55]

Calligraphy, on one hand, is the art of the stroke, something that is not merely a line whose function is to outline objects, or to be a border between the contents and the contour of things; the stroke simultaneously implies volume and shape, rhythm and the movement. Thanks to this technique, the artist rapidly assumes an efficient means of expression, simple and intense.

Regarding his way of transcribing light with hues of colour, Pe Kim owes a lot to the experience of the Western masters, but also to his Christian faith, since his search is not only oriented towards the effect of light, but towards the source of light itself which, for him, is of divine origin.

This is why it may be said that the Dominican finds himself at the junction point of various civilisations, of opposite worlds which he got to know, to tame, and where he rightfully managed to bring his work to life. The soaring lyricism of his

54. K En Joong, *Unity*, 36.
55. François Cheng, in the documentary *The fragility of solid things*, https://www.youtube.com/watch?v=oA-_gvML1xc, min. 8:00.

paintings confers new sounds to shapes and colours, but it also brings on the image of an afterlife that inevitably leads to contemplation.[56]

The landscapes of his homeland, the way in which his people conceive the world, the experiences lived in his first years, the calligraphic technique, and his inner philosophy blend together in each painting with the answers found in the West, with the new world revealed by his faith in Christ, with the great Western masterpieces and with his own artistic search. All this is present in Pe Kim's art. Furthermore, one can perceive the combination of links which the artist has managed to establish with great simplicity between all these elements, in order to turn the ensemble, the whole experience, into a starting point towards the beyond, towards the mystery of God and of the human person.

56. 'Elle s'inscrit à la jonction de plusieurs civilisations, de mondes opposés, qu'il a appris à connaître, à apprivoiser, et dont il a su, à juste raison, faire vivre son œuvre. Les envolées lyriques de cette peinture donnent des sonorités nouvelles aux formes et aux couleurs, mais également l'image d'un au-delà qui conduit inévitablement à la contemplation.' Jean-Louis Prat in K En Joong, *Kim En Joong: Paris-Tokyo*, 6.

Commentaries on the Works of Kim En Joong OP

> If angels were to paint, their art might be like that of Kim En Joong: radiant, luminously beautiful, ecstatic in its freedom. Colour and form seem almost to have appeared by virtue of their inherent truth, not so much created by Father Kim but summoned from the depths of his prayer (Sister Wendy).[1]

One of Pe Kim's books begins with this comparison by Sister Wendy.[2] This is a very appropriate starting point for this section, where the theological significance of the artist's work will be developed, as it directly connects the Dominican brother with the pictorial tradition of his Order, in particular with his predecessor Fra Angelico.

As mentioned earlier, Pe Kim's art stems from contemplation, from prayer and from what he considers to be true preaching of grace, a deeply Dominican concept. He humbly explains it himself as follows:

> I do not pretend to be an angel: my artistic action is merely the effort of a prodigal son who wishes to rise and join the Father. My meditation on the Beatitudes makes me rejoice and be glad like St Dominic, who wanted his sons to act on the entire universe.[3]

1. K En Joong, *Unity*, 4.
2. Carmelita, famous historian and art critic, in J Thulier, *Kim En Joong, Peintre de*, 202.
3. 'Je ne prétends pas faire l'ange: mon action artistique n'est que l'effort d'un enfant prodigue qui veut se lever et aller vers le Père. Ma méditation sur les Béatitudes me fait entrer dans la joie et l'allégresse de saint Dominique qui voulait que ses fils agissent sur l'univers entier.' K En Joong, *Bruxelles-Paris*, 4.

He was, and still is, shown similar recognition by his brothers, among whom the Master General, Fr Timothy Radcliffe:

> Thanks to his creative work, brother Kim acts as a preacher, thus forming part of a long list of Dominican artists who, in one way or another, have announced the mystery of the living God and the Creation. How can one express the depth of the Paschal mystery, from the distress on the cross to the joy of the Resurrection, a mystery always at work in our lives and in the whole universe? How can one express the fear and happiness that the singularity of our condition causes us, those times of unrest in which we become aware of our frailty, those moments of grace in which we are visited by the unknown? We are moved by so many expectations and faces, by so many shadows and lights![4]

And another former master General of the Order, now Bishop Carlos Azpiroz:

> But I know that what counts for you, beyond any mundane recognition, is that these paintings, these stained-glass windows, these lithographs be means offered to those who see them, so that they can sense the Spirit that moves you and that lives in them, even if they are not aware of it. It is fortunate that, among all forms of preaching used by the Preachers, art be present, for it enters where words cannot go and it binds with beauty the hearts of the spectators.[5]

4. 'Par son travail créateur, Frère Kim fait œuvre de prêcheur, s'inscrivant dans une longue suite d'artistes dominicains qui, de diverses manières, ont annoncé le mystère du Dieu vivant et de la création. Comment dire toute la profondeur du mystère pascal, depuis la détresse de la croix jusqu'à la joie de la résurrection, mystère toujours à l'œuvre en nos vies humaines et dans l'univers entier? Comment exprimer la crainte et l'allégresse que produit en nous la singularité de notre condition, ces temps d'inquiétude où nous saisissons notre fragilité, ces moments de grâce où nous visite l'inconnu ? Nous sommes habités par tant d'attentes et de visages, par tant d'ombres et de lumières!' Fr. Timothy Radcliffe, in K En Joong, *Kim En Joong*, 9.

5. 'Mais je sais que pour vous ce qui compte, bien au-delà d'une reconnaissance mondaine, c'est que ces tableaux, ces vitraux, ces lithographies soient autant de moyens mis à la disposition de ceux qui les voient pour qu'ils pressentent l'Esprit qui vous anime et qui les habite, même s'ils n'en sont pas conscients. Il est heureux que parmi toutes les formes de prédication qu'utilisent les Prêcheurs,

Proposal of Active Participation

This preaching in question is particularly significant in today's world. Amidst a culture that increasingly rejects any type of imposition, Pe Kim's abstract painting first presents itself as a suggestion, an invitation.

> Father Kim has chosen this path. Through his non-figurative art he has cultivated a path towards the beauty of God, without making it a topic of discussion, letting the spectator follow lines, meanders and colours that impose nothing, but suggest everything. This lack of apologetic concern is a discreet yet meaningful reference to the Supreme Beauty: 'a Beauty so ancient and so new', as Saint Augustine used to say. This truth seeker also knew without a doubt that beauty is the halo of truth; it is like the sun's corona, in which the intensity of light and heat comes from the heart of the flames itself.[6]

Such a proposal does not require the spectator to have a religious background, which often bears a heavy load of negative prejudices in our societies, but which nevertheless offers an opening onto the worlds of interiority and spirituality. Living in faith also facilitates meeting Transcendence, an encounter our contemporaries desperately need:

> Father Kim's art takes place in this universe of mystery of God and man; it draws the curtain to reveal the invisible world, to let us in . . . And we enter with curiosity, with gratitude; may we thank the Lord for having given the Church and the

l'art soit présent car il entre là où nos paroles ne peuvent aller et rejoint par le beau le cœur des spectateurs.' Fr Carlos Azpiroz Costa, in J Thulier, *Kim En Joong, Peintre de*, 200.

6. 'Le père Kim a choisi ce chemin. Par son art non figuratif, il cultive un chemin vers la beauté de Dieu, sans rien thématiser en laissant le spectateur suivre les lignes, les méandres et les couleurs qui n'imposent rien, mais qui suggèrent tout. Cette absence de préoccupation apologétique est un renvoi discret et puissant vers la Beauté suprême: Beauté si ancienne et si nouvelle, comme le disait saint Augustin. Ce chercheur de la vérité savait d'ailleurs que la beauté est le halo de la vérité ; elle en est comme la couronne solaire, dont l'intensité de lumière et de chaleur provient du cœur même de ce brasier.' K En Joong, *Kim En Joong: Paris -Tokyo*, 13.

world such an artist, a mediator who can help us access the invisible.[7]

The language of abstraction, although we are not accustomed to it, turns out to be an excellent way to communicate and share the Mystery. The essence of God itself escapes any conceptual control; that is why images and symbols already abound in the Scriptures. The figurative representation of this allegorical world reduces and limits its deep significance—and even more so when we look at it with our Western mentality. However, what cannot be expressed by concepts and words can be said with colours, lines, and shapes. The concept explains, the image suggests:

> Only images and symbols open us up to the invisible world, and the artist is the guardian of the gate leading to the garden of those things that lie beyond us. Even if he is not aware of it, or is not willing to acknowledge it, he alone holds the keys to enter into the Realm of God and the depths of mankind.[8]

With their vibrant colours, the paintings of our artist lead us into a spiritual process. From his own experience and inner life, the artist acts like a 'seer' who offers us an irradiation of light, shapes and colour that do not force a determined message onto us, but that prove to be tremendously inspiring, given that they appear with the strength of their own truth.

Kim himself acknowledges the fact that the seed of each work does not reside in him. What he paints comes to him as a gift, he feels like an instrument in the hands of God: 'I am not afraid. I have confidence, not in myself, but in what is about to pass through me. Today,

7. 'L'art du Père Kim prend place dans cet univers du mystère de Dieu et de l'homme; il tire le rideau qui cachait le monde invisible pour nous permettre d'y entrer . . . Et nous y pénétrons avec curiosité, reconnaissance; rendons grâce à Dieu d'avoir donné par cet artiste à l'Eglise et au monde, un médiateur pour accéder à l'invisible.' K En Joong, *Kim En Joong: Rouen*, 3.

8. 'Seuls l'image et le symbole ouvrent sur le monde invisible et l'artiste est le gardien de la porte menant à ce jardin des choses qui nous dépassent. Même s'il ne s'en rend pas compte ou hésite à le reconnaître, lui seul possède les clés permettant de pénétrer dans le Royaume de Dieu et des profondeurs humaines.' K En Joong, *Kim En Joong: Rouen*, 2.

I don't know what I will be painting tomorrow, and it doesn't concern me in the slightest!'[9]

Thus, contemplating a painting by our artist is a spiritual process in which the main actor is the spectator himself. This is an offer of great significance in our current mindset in which the human being does not accept impositions, wishes to experiment for himself, and to be the protagonist of his faith.

Today, faith has gone from being a socio-cultural imposition, or an inherited attachment, to a personal experience, a free adhesion of individuals to a God who comes to them in their own stories and experiences.

This also implies discovering the possibility of maintaining a personal relationship with Christ. It may even entail a reconciliation with the Scriptures, which people are slowly learning to understand and to incarnate in their own lives; a development of individual consciences, apt to differentiate what is consistent with this God, whose presence they are discovering bound to them, and what responds to institutional interests that have already been overcome.

Henceforth, it also implies a considerable enrichment of the ecclesiastic life with a greater participation of a laity that no longer can nor wants to play a passive role, but that discovers itself capable and trained, demanding a noteworthy role in its plurality and respect towards its own diversity: '. . . after having clearly asserted that the Church is no democracy, we must promptly add that it is even less a dictatorship. It is a peculiar type of government in which many traits of modern democracies may and must find a place.'[10]

Pe Kim's painting supposes that impositions no longer make any sense, nor do rigidities or uniformities; it is more constructive to highlight the importance of an authentic form of freedom, to show how one can be truly free, through the prisms of one's choices, commitments, and responsibilities. Such values are fundamental for the believing community: 'This would imply an intra-ecclesiastic opening to co-responsibility, respect towards pluralism, freedom of expres-

9. Personal testimony of the artist in the documentary *Lights and colours*, https://www.youtube.com/watch?v=ap66sWDvzrI&feature=youtu.be, min. 25:38.
10. L González-Carvajal, *Ideas y creencias del hombre actual (Ideas and beliefs of modern man)* (Santander: Sal Terrae 1996), 107.

sion, transparent information, access to judicial guarantees, and the participation of the faithful in the election of pastors.'[11]

With the abstraction of his paintings, Kim avoids shapes not only in the figurative sense, but also in the normative sense. By doing so, he opens up to the responsible freedom of him who observes, allowing the spectator's interest, his own spirit, to recreate the work of art:

> The disturbing strangeness dissolves in the abyss of the subconscious, and it is the Ego that survives, dictates the answers.
>
> Everything depends on the Ego.
>
> If it is sombre and harrowed like sienna, a plant dream will take it into an imaginary forest, where the filaments of a giant mycelium push up in the midst of monstrous water plants (...)
>
> But if the Ego is joyful and uplifted by happiness, if purple and blue, jade and lilac, willow-green and orange make the colour-lover quiver, then he shall see stalks, leaves, maybe the corals of a lagoon, the nymphea of a heavenly pool, the dyer's wools laid out at the souk, carnival floats, images of psychedelic exhilaration, the voluptuous twirls of Salome's dance, her humming-bird-down slippers, the brilliance of her mandrake-embroidered veils, and the flashes of her silver-sheathed leg.[12]

Consequently, it is an invitation to search, to meet and to freely adhere to God, to a love that can never be imposed—because the very essence of love is to bloom only when it is born free:

> The great mistake along the way is to submit to forms. Who submits to forms loses his initiative, his creativity, his spirit of inquiry (...)
>
> This defines any true religious endeavour: the path is true when it frees us from forms, when it breaks all submission.[13]

11. González-Carvajal, *Ideas y creencias del hombre actual* 108.

12. K En Joong, *Rêves*, 37–38.

13. 'El gran error en el camino es someterse a las formas. Quien se somete a formas, pierde su iniciativa, su creatividad, su espíritu de indagación (...) Este es criterio

In the documentary *La fragilité des choses solides* (The fragility of solid things*)*, Cardinal Barbarin, Archbishop of Lyon, expresses the fact that in Pe Kim's painting, in his colours, resides the very life of the artist; his prayer is present, his work . . . and this presence ends up touching the spectator in his inner self. If he who looks at a painting freely accepts the invitation, he will find the answers he is intimately seeking, he will be able to satisfy his deepest longings: 'Let the colours bring you the light you need, then we shall walk our path.'[14]

Proposal of Mystic Spirituality

As shown previously, we find ourselves confronted with a work that is charged with mysticism. The need for spirituality in present days was already announced in the last century by French novelist A Malraux, who is said to have asserted that 'the twenty-first century will be mystical or it will simply not exist'. Karl Rahner repeated the same idea applying it directly to the life of the Church: 'Tomorrow's religious person will be a mystic, a person who has experimented something, or he will not be able to carry on being Christian. Tomorrow's Christian will be mystic or will not be Christian.'[15]

Amidst our consumerist and materialistic culture, it is becoming obvious that a deep dissatisfaction is growing among our contemporaries, a thirst that earthly goods cannot quench. Pope Francis spoke of this reality in his first Apostolic Exhortation, *the Joy of the Gospel*: 'The great danger in today's world, pervaded as it is by consumerism, is the desolation and anguish born of a complacent yet covetous heart, the feverish pursuit of frivolous pleasures, and a blunted conscience.'[16]

In spite of the risk that this quest for interiority might eventually turn into a new form of hedonism, a mere consumption of gratifying experiences and sensations, or into a stoic isolation, which has

del verdadero camino religioso: es verdadero el camino que libera de las formas, el que quebranta toda sumisión.' M Corbí, *Religión sin religión* (Madrid: PPC, 1996), 112.

14. Cardinal Barbarin, in the documentary *The fragility of solid things,* https://www.youtube.com/watch?v=oA-_gvML1xc, min. 18:18.

15. K Rahner, *Ancient and modern spirituality*, in *Theological investigations*, volume VII, (Modern: Taurus, 1969), 25.

16. *Evangelii Gaudium*, n. 2.

nothing to do with God or with the reality and pain of others, we cannot cease to consider this necessity of our time like a challenge for believers.

After having been disappointed by his confidence in the so-called complete explanations of science and reason, and deceived by the comfort brought on by human technology, man seems to be re-discovering himself in his wholeness and his own mystery. He is becoming aware of the fact that, deep down, he has needs that are not material. He is breaking the monopoly of empiricism and starting to acknowledge and to accept the existence of different ways of comprehending his own reality and that of the world.

The answer to this is expressed by Pe Kim as follows:

> I do not paint rational things, but sensations. Intimate sensations cannot be explained, I experience them in my painting. The world is flooded with images of all sorts and with figurative representations; I seek a non-polluted world, which I find in mystery, and I express it in my paintings.[17]

This enables him to offer the choice of a real spirituality, one aimed at meeting Transcendence, incarnated on Earth, and ruled by the principle of a god who comes to us. An interiority that sees the world and its reality as a place of contact, and by extension, that inevitably tends towards an implication with and a transformative commitment towards the environment in which we live.

Being given such an opportunity, our artist's canvasses show us a much broader and superior reality, which connects with the depths of the human being, with his true nature, where it is possible to reach the fullness and happiness longed for by all:

> The Creator fashioned a creature in the Garden of Eden that was amphibious, both body and spirit. Most art today has to do with just the body, the material, earthly matters, but Kim En Joong's art has to do with the spirit, another realm of reality.

17. 'Je ne peins pas des choses rationnelles mais des sensations. La sensation intime ne s 'explique pas, je la vis dans ma peinture. Le monde est envahi d'images de toutes sortes et de représentations figuratives, je cherche un monde non pollué, que je rencontre dans le mystère, et je l'exprime par ma peinture.' K En Joong, *Bourges* (Paris: Cerf, Paris 2012), 16.

Kim is a modern artist who has never denied the earthly
things in life, but as a Dominican monk he has been inspired
by this other realm of reality. Kim himself has been inundated
by the Holy, the élan vital, the numinous, the mysterium
tremendum. His art is beyond super-mental consciousness
and it takes a second language to describe it. Even a 'diet of
words' cannot adequately portray his miraculous paintings.[18]

A thorough contemplation of each of his canvasses is an invitation to
go further, to seek out another way of life that might grant everyone
more humanity. This message of 'alternatives' is essentially Christian;
in fact, it has been recently underlined by Pope Francis:

In a society so often intoxicated by consumerism and
hedonism, wealth and extravagance, appearances and
narcissism, this Child calls us to act *soberly*, in other words,
in a way that is simple, balanced, consistent, capable of seeing
and doing what is essential. In a world which all too often
is merciless to the sinner and lenient to the sin, we need to
cultivate a strong sense of justice, to discern and to do God's
will. Amid a culture of indifference which not infrequently
turns ruthless, our style of life should instead be devout, filled
with empathy, compassion and mercy, drawn daily from the
wellspring of prayer.[19]

The luminosity, the joy and the mystery of his paintings show us the
realms of spirituality and faith in a new, modern, sincere and direct
way; these elements communicate a true spiritual experience. This
practice springs up from the roots of the Dominican Order and
appears in the thought of various Dominican authors, such as Fr
Arintero:

Arintero believes that if our religion were expounded to
them in a positive way, like a source of infinite light or an
inexhaustible fountain of life, if it were shown to them as it
really is, as an irradiation of the infinite life and love of a God
enamoured of our poor souls, many of its enemies would

18. John J Weaver, Archdeacon of California in K En Joong, *Unity*, 6.
19. Pope Francis, Homily of the Midnight Mass, December 24th, 2015, https://
w2.vatican.va/content/francesco/es/homilies/2015/documents/papa-
francesco_20151224_omelia-natale.html

show appreciation and interest for it. If it were presented in such a way, it would lead to the understanding that we cannot be complete without being perfect Christians; indeed, as Saint Augustine used to say, there are no other perfect people than God's true sons.[20]

In this sense, Pe Kim's work takes up the evangelical challenge of 'being born again',[21] a process that is also suggested by the dynamism of his works and that has to start with the transformation of the spectator's personal interiority:

> Cardinal Murphy–O'Connor of England and Wales has described the old world, where the 'language of Christianity as a background for people's lives and moral decisions, and for governments and the life of countries has vanished and become bankrupt.' This is also true for Judaism and Islam. The old words have lost their meaning, their sense of purpose and destiny; we are in a dark wood and don't know which way to turn. We need to experience art like Kim's, which gives us glimpses and visions of a new world of grace and beauty. If we, in silence, sit in the Cathedral of Grace and meditate in this new language as expressed in art, we may experience the Holy, perhaps the face of God, or as Moses said in Exodus 33:23, 'His backsides'. This experience may bring new meaning and purpose and sense of destiny . . . actually, a new birth.[22]

Thanks to the forms that unfold and expand on the canvas, very gently Pe Kim's paintings open up our souls, showing us the purity and joyful beauty of this act, making us long for this experience, so distant from the isolation and egoism that prevail around us:

> Whenever our interior life becomes caught up in its own interests and concerns, there is no longer room for others, no place for the poor. God's voice is no longer heard, the quiet joy of his love is no longer felt, and the desire to do good fades. This is a very real danger for believers too. Many fall prey to

20. MA Martínez de *Juan González Arintero: Entre Salamanca y Valladolid*, http://www.dominicos.org/grandes-figuras/personajes/juan-gonzalez-arintero/entre-salamanca-y-valladolid.

21. Jn 3:1–36.

22. K En Joong, *Unity*, 6.

it, and end up resentful, angry and listless. That is no way to live a dignified and fulfilled life; it is not God's will for us, nor is it the life in the Spirit which has its source in the heart of the risen Christ.[23]

When he is far from fear, complexes and insecurity, a human being can meet with himself and discover with clear eyes the tremendous beauty that resides inside him. This is when a change occurs in his way of contemplating the world and of relating to it, to the other, and to the mystery:

> Plato spoke of the Theia mania—the divine madness. Experiences which advance human life to its true fullness are those which are 'God-given'.
>
> When one is beside oneself (ecstatic) our real inheritance as human beings is enjoyed, achieved, and preserved. This is done only through a willingly accepted openness for divine revelation (and if you don't care for the 'God' language, think of the artist being taken over by or lost in the Other). There is also the salutary pain of catharsis. Great art comes at great cost. Some would say that the great gift of art is the emotional shock brought about by love (as both ecstasy and simple caring for others). However we interpret the purpose of art, it has something to do with challenging and stretching the human spirit.[24]

In such a way that:

> We become fully human when we become more than human, when we let God bring us beyond ourselves in order to attain the fullest truth of our being. Here we find the source and inspiration of all our efforts at evangelization. For if we have received the love which restores meaning to our lives, how can we fail to share that love with others?[25]

Spirituality frees us from all the burdens we have accumulated in this world, enabling us to face misfortunes and difficulties with serenity,

23. *Evangelii Gaudium*, n 2.
24. K En Joong, *Unity*, 33.
25. *Evangelii Gaudium*, n 8.

and to experience the fact that true joy is the human person's essence, that it does not only stem from or exist in the material world:

> Father Kim's art is full of energy and joy, radiating the rhythm of emptiness and fullness which reflects the wisdom of all the great spiritual traditions—all of which cries out for a great space to be fully appreciated.

> This exhibit is truly a celebration of the human spirit at one with nature, with itself and with God.[26]

As we can see, Pe Kim's work is deeply spiritual, from its very origin. But it is also a form of mysticism that offers the spectator answers to his modern-day yearnings and voids.

Proposal of Dialogue and Search for Truth

There is another element that lays the ground for Kim En Joong's work and that flows out of his spirituality: he proposes a dialogue between those who are different, an opening to understanding that ultimately burns down to a search for Truth.

This attitude characterises all Dominicans, but in this case, it is also the lesson he has learned from his own experience. From the pain caused by the separation within his country, to the reconciliation of his native culture with the European one, and to the integration of his two vocations into one, which he masterfully communicates on his canvasses:

> His art brings together East and West, the abstract and the concrete, the longings of the human spirit with the splendor and passion of nature. There is an energy and integrity here for which the world longs; and the marriage of the disparate and, hitherto, warring elements of human experience is timely as we seek to reimagine the world where there is peace, justice and harmony.[27]

26. Alan Jones, Dean of Grace Cathedral, San Francisco, and Canon of the Cathedral of Our Lady of Chartres in K En Joong, *Unity*, 5.
27. K En Joong, *Unity*, 5.

Within the figure of Pe Kim, many encounters occur: various cultures meet, but also art and faith, religion and society, contemplation and action . . . And all this is captured in his work, which, according to artist Joël Damase,[28] is the main peculiarity of the artist's productions: 'What characterizes Pe Kim is that there is no difference between him, his life and his work.'[29]

From here, the Dominican's painting is at the same time a hand stretched out towards dialogue, unity between different people, and a common search for Truth.

By using a language that is completely distinct from the one we are used to in the ecclesiastic field, the artist rids himself of any anterior reference or underlying prejudice, of any pre-established norm, so that his proposal can be deemed valid to enable everyone to come together and communicate: 'In these times that many qualify as restorationist, it is perhaps not superfluous to recall that the prerequisite to be able to engage in a dialogue with today's culture, is to abandon the synthesis of faith and culture bequeathed by past generations.'[30]

This dialoguing attitude, this opening to meeting the other necessarily situates the entirety of his work in a constant tension between opposites, in an unwavering balance. This offer can be perceived in his paintings, throughout the balance between the lines, shapes, volumes and colours. A balance between the said and the unsaid, between words and silence: 'Kim En Joong's painting expresses the deep knowledge and understanding characteristic of a humanism that is too often forgotten. It speaks of the relevance of a language that can be offered to those that everything seems to set apart.'[31]

This spirit is necessary for today's world and Church, where global communication is a fact, as is the knowledge and coexistence of other beliefs, of a great number of ways of understanding life and the world. In this sense, we live in a setting that may be positive in principle, but that is not exempt from dangers to which we can also be painfully

28. Photographer, author of the book *Brioude, la Basilique de Saint Julien* (Paris: Cerf, 2009).
29. Joël Damase, in the documentary, *The fragility of solid things,* https://www. youtube.com/watch?v=oA-_gvML1xc, min. 49:07.
30. L González-Carvajal, *Ideas y creencias*, 32.
31. 'La peinture de Kim En Joong exprime la connivence et la connaissance profonde d'un humanisme trop souvent oublié. Elle dit la pertinence d'un langage qui peut être livré à celles et à ceux que tout semble séparer.' K En Joong, *Kim En Joong: Paris-Tokyo*, 7.

exposed. It is natural that the encounter with the 'other', the one who is different, should make us doubt, or even frighten us. Becoming familiar with other credos can lead to losing the absolutistic character of one's own faith, to being confused by the belief that 'anything will do', or to wavering in one's own convictions; on the other hand, it can also entail the radicalisation of positions, the creation of *ghettos,* or the proliferation of fundamentalisms.

The stepping stone of Pe Kim's proposal is the conviction that encounters and authentic dialogues always bring us truth and help us grow: 'Through art, I want to achieve the deep unity of humanity, naturally, without flattery.'[32]

His trust in communication stems firstly from the certainty of his own faith, but also from his awareness of the deep need for unity that exists as well in man's inner self as within our society, and in the whole world: 'Kim En Joong would never have gone into painting or, a fortiori, religion, had he not, by devoting himself to them, drawn an assurance of uncovering the secrets of the vital balance in them . . .'[33]

He communicates his experience of a God who was not imposed upon him by force, who, on the contrary, captivated him in a subtle way, approaching him from the most unexpected angles. 'To delve deep into the God who is dialogue and tolerance, who communicates with the human being but never imposes himself, who leads us to come together, to practice listening and understanding the Other.'[34]

The entirety of Pe Kim's work makes up a great unity, a universe in which each painting offers its own identity and message, but also fits into a broader, more complete and certain harmony:

> Every one of these canvases has its place here and each plays its part freely, respects the presence and the diversity of all the others in their shared unity. All of these works complete each other. It is not their aim to provoke demands for explanations. They are, rather, an invitation to discover a hidden world. A world of clarity, of proportion and integrity, in accord with St Thomas Aquinas's 'Treatise on Beauty'.[35]

32. K En Joong, *Bruxelles- Paris*, 18.
33. 'Kim En Joong would never have gone into painting or, a fortiori, religion, had he not, by devoting himself to them, drawn an assurance of uncovering the secrets of the vital balance in them . . .' K En Joong, *Bruxelles- Paris*, 12.
34. JM Mardones, *Matar a nuestros dioses. Un Dios para un creyente adulto,* (Madrid: PPC, 2007), 173.
35. AA.VV., *Kim En Joong, 80ème Anniversaire,* 8.

In this way, we are shown a display of humility that goes hand in hand with an authentic experience of faith, that prevents us from feeling superior to others, enables us to comprehend the logical limitations of our understanding as creatures, and favours dialoguing with other faiths, thus purifying our interpretation of all which was revealed and freeing it from any cultural, merely institutional or historical elements.

In such a moment of inter-confessionalism, many evangelical teachings become evident:

> I assure you that there were many widows in Israel in Elijah's time, when the sky was shut for three and a half years and there was a severe famine throughout the land. Yet Elijah was not sent to any of them, but to a widow in Zarephath in the region of Sidon. And there were many in Israel with leprosy in the time of Elisha the prophet, yet not one of them was cleansed—only Naaman the Syrian.[36]

And also: 'Produce fruit in keeping with repentance. And do not begin to say to yourselves "We have Abraham as our father." For I tell you that out of these stones God can raise up children for Abraham.'[37] A convinced stance, yet simple and open to the other, that avoids any type of fundamentalism: the belief that Truth resides only in our own comprehension, that we possess it completely, or that any other belief is completely wrong and must thus disappear. On the contrary, far from posing a threat, those who believe or think differently become necessary contributors on our path towards Truth. This has been understood in the Dominican Order since its very beginnings: 'Every truth by whomsoever spoken is from the Holy Spirit.'[38]

Pe Kim's work is equally instrumental in bringing the Church and the world of the arts together, in re-establishing the communication between faith and culture, in searching for a mutual collaboration that has always benefitted both fields, in creating good conditions upon which to base a search for an authentic dialogue, a task that the current generations cannot elude.

36. Luke 4 :25–27.
37. Luke 3:8.
38. *ST.*, I-II, q. 109, a. 1, ad 1.

This being said, a true interchange, an understanding within diversity is an indispensable premise to reach a truth that can never be totally possessed, but that is a continuous, shared quest: 'Truth can be sought, but cannot be possessed. From here stems the diversity of paths leading to Truth. And the possibility of unity, in keeping with plurality and freedom.'[39]

All the above can also be perceived inside each painting, where a same colour shows different intensities and can fill the space in various degrees. At some point, it can be a deep pigment, full of life, yet at others it may seem to evaporate. All colours, each in its own way, relate to the rest in the general composition; they come together or move apart, as in a conversation or a dance, seldom blurring each other in such a way that they should lose their intensity, rather always strengthening each other mutually and working together to capture the omnipresence of light. Because Light, in Kim En Joong's work, is a synonym of Truth.

Maybe that is why our artist's paintings fascinate the public, because each human being carries deep down a passion for Truth. 'Many paths lead to God. The first one is the path of Truth.'[40]

For us, God is Truth itself: he who seeks the Truth is treading the path of God. However, in today's world, this quest runs into a fundamental difficulty: the issue of relativism questions the existence of a single truth, valid for everyone.

> For our contemporaries, this path meets an obstacle: that of scepticism. What is Truth?
>
> This question is on the lips and in the heart of every man, son of his times. There are plenty of 'Pilates' nowadays.
>
> The path towards Truth remains viable. But it is no longer the favourite path of most of our travel companions.[41]

39. JM Mardrones, *Matar a nuestros dioses,*173.
40. 'Il y a beaucoup de chemins vers Dieu. Le premier est le chemin de la Vérité.' K En Joong, *Kim En Joong: Paris-Tokyo,*12.
41. 'Pour nos contemporains, ce chemin rencontre un obstacle: celui du scepticisme. Qu'est-ce que la Vérité? Voilà une question qui est sur les lèvres et dans le cœur de chaque homme, fils de son temps. Les «Pilate « sont nombreux par les temps qui courent. Le chemin de la Verité reste praticable. Il n'est plus le chemin préféré de la plupart de nos compagnons de route.' Cardinal Godfried Danneels, K En Joong, *Kim En Joong: Rouen-Paris,* 12.

The way of goodness is not a very popular one in our times either. God is goodness and moral perfection. He is sheer saintliness.

But modern man feels weak and morally fragile. He is not saintly, and to him, saintliness is not only unattractive, but (it is) even disheartening/discouraging. In a society which seemingly celebrates the triumph of competitiveness, corruption, material riches or fame at any price, the way towards good and moral perfection to reach God is rarely practiced.

Things are different when it comes to beauty; God is infinitely beautiful. The path of beauty is still walked on today, and it continues being a place where Transcendence can be met. This is the common field where Pe Kim deems a dialogue to be possible: 'The sudden invasion of faith lightened the burden of the "low and heavy sky" that weighed down on the human condition: by fusing into beauty, art and faith then took up the entire space. The Absolute reined supreme!'[42]

Beauty is a space in which each person can participate, in that it exercise a powerful attraction over all, and because it is desired and needed in today's world, as stated by Pope Benedict XVI: 'What is capable of restoring enthusiasm and confidence, what can encourage the human spirit to rediscover its path, to raise its eyes to the horizon, to dream of a life worthy of its vocation—if not beauty?'[43]

In beauty, one can find a shared hope, a model of personal development, and a common goal which the human race can aim at as an individual person. But it has to be an authentic concept of beauty. In the speech quoted above, Benedict XVI described this idea like something awakening a deep desire to love, to go beyond oneself, and to keep searching always further.

Pe Kim's work affects us in our most intimate corners, showing us that our own mystery transcends us. As noted previously, a detailed contemplation thereof opens our eyes to a new vision in which meeting God becomes possible:

42. 'L'invasion soudaine de la foi allégea le poids de ce "ciel bas et lourd" pesant sur la condition humaine: l'art et la foi en fusionnant dans la Beauté occupèrent alors tout l'espace. L'Absolu régnait en maître!'. JC Pichaud, *Kim En Joong et le Cabanon*, 15.
43. Benedict XVI, *La belleza camino hacia Dios, encuentro con los artistas*, 21 noviembre 2009, en https://w2.vatican.va/content/benedict-xvi/es/speeches/2009/november/documents/hf_ben-xvi_spe_20091121_artisti.html

The beautiful God is infinitely desirable. It is not rare that
youngsters who have just attended the St Matthew Passion
by Johann Sebastian Bach, should forget their doubts and
scepticism, and henceforth cease to think about the moral
effort required to find God. They know it after this course of
Beauty.[44]

In front of a painting by Pe Kim, we are left with a feeling of rec-
onciliation that demands no explanation and enables us to become
absorbed in the pursuit of this special journey, in a spellbinding med-
itation about a presence existing beyond words, beyond colours, in
the silence of its singular whites, the bearers of a universal chant, of
unique notes, the music of another world.

Proposal of Joy and Optimism

St Bernard tells us that there are three books from which
we might learn something of the great purposes of God:
the Book of Scripture, the Book of Nature, and the Book of
Experience. Father Kim, by his profession as a Dominican,
is committed to a life shaped by the Scriptures and his art,
in many ways, is his reading of the other two great 'books'.
He takes the elemental forms of nature and forges them into
vibrant abstract statements, which speak to the imagination
and the heart. They are also a celebration of the marriage of
East and West, exulting in the natural world and, because
of their abstract form, an expression of the two ways of the
spiritual life: the way of images and the way of the negation
of images. Art—like life—is both accessible and inaccessible
at the same time. It is palpably present to us and yet always
mysterious. And these paintings are an expression of an open
spirituality, expressing possibility and hope.[45]

44. 'Le Dieu beau est infiniment désirable. Il n'est pas rare que des jeunes qui viennent
d'assister à la Passion selon saint Matthieu de Jean-Sébastien Bach, oublient
leur doute et leur scepticisme, ne pensent plus à l'effort moral à accomplir pour
trouver Dieu. Ils le savent au bout de ce parcours de beauté.' K En Joong, *Kim En
Joong: Paris-Tokyo*, 12.
45. K En Joong, *Unity*, 34.

These words of M Alan Jones, dean of the Grace Cathedral in San Francisco, summarise everything that has been presented in the previous sections, yet they also present us with a new proposal to read Kim En Joong's work: it is 'good news' for the world, as it is full of hope, freedom and future.

It is a preaching of grace that can only be transmitted by someone who knows he has been personally touched by it, who is aware that his own vocation as a preacher is already a manifestation of grace.

This is the feeling in which Pe Kim lives, grateful for the gift of faith, for his vocation and his art, for all the friendships, brothers and possibilities he was given, and this gratitude is another one of the central elements of the message conveyed by his work:

> This year is the fortieth year of my life as an artist and this exhibition contains canvases which reveal my universe and portray my commitment to moving forward constantly in hope and thanksgiving. Three circular canvases evoke a world of happiness. Does the sphere not symbolise the beatific vision, the infinite, the mobile in the unmoving? These canvases render homage to the theological virtues: Faith, Hope and Charity.[46]

This joy and gratitude are owed, as is to be expected, to the circumstances he has been granted, especially on his spiritual path, and to his encounter with God who—by means of beauty—conquered his heart progressively and led him to devote himself to Him. He is grateful also for the gift of his artistic talent, that enables him to express and to share his inner world: 'Happy is the man who has two ways to exchange with his brothers, while so many beings are deprived of even a single one of these faculties!'[47]

Yet even if he sees this double channel of communication as a gift, it still requires an effort on his behalf, namely to go through the difficult process of bringing both his spiritual and his artistic expression into harmony while developing each one individually:

46. AA.VV., *Kim En Joong, 80ème Anniversaire*, 8.
47. 'Heureux homme disposant de deux moyens d'échanges avec ses autres frères alors que tant d'êtres sont dépourvus d'une seule de ces facultés!' Kim DAE JOONG en K EN JOONG, *Kim En Joong: Rouen*, 4.

> Happy with his lot in life and, even more so, with the freedom to be won over by the palette in his hand, he prepares you for battle simply by singing a never-ending hymn in recognition of the Lord on paper, line after line, rhythm after rhythm. Without vulgarity, without superfluous expression and without devotional statuary.[48]

These words by M Roger-Pierre Turine[49] highlight the fact that the joy at issue is also an offering to the public. Nonetheless, this gesture must transcend the artist's own living conditions, since these do not apply to the spectators.

In fact, the fullness and hope transmitted by Pe Kim's work are not only founded upon his personal and professional successes since, as we have already pointed out, he has also experienced great sufferings and deprivations. Here we are not dealing with a naive joy, but with one that emanates from hope, in full consciousness.

M Alan Jones refers to this quality as follows:

> Anthony Storr tells us 'Becoming what one is a creative act comparable with creating a work of art'. It is freeing oneself from the tyranny of one's upbringing; emancipation of oneself from convention, from education, from class, from religious belief, from all the social constraints, prejudices which prevent one realizing one's own nature in its totality. I experience Father Kim's work as an act of liberation and celebration. His work is a great 'Yes!' to life without naiveté or sentimentality, in a world where the 'No!' receives too much attention.[50]

Thus, our artist's work is an invitation to freedom. When we contemplate his art, we must let go of any charge that might be burdening us, in order to be able to meet in life with light-filled colours dancing with each other, with our own selves in our simplest nakedness, and consequently, in the our purest truth.

To find ourselves in all our beauty in the light of God and, from there, to contemplate the whole world and our brothers. To show the light of God implies also showing the deep beauty of the Creation and of Man, in order, inevitably, to trust, to believe and to lay hope in Him. This is the joy that Pe Kim offers us.

48. K En Joong, *Bruxelles- Paris*, 16.
49. Art critic and member of the International Association of Art Critics (AICA).
50. Alan JONES en K. EN JOONG, *Unity*, 34.

A Significant and Modern Proposal

To finish our analysis on Kim En Joong's work, we must highlight its function as a bridge, as a very necessary means of communication between the ecclesiastical world, that of faith, and the spheres of culture and contemporary art.

Not only does our artist not hide his Dominican brotherhood, but he is even accustomed to attending inaugurations and various public events wearing his habit:

> 'Whether he dons the friars habit or sheds it to paint, Fr Kim certainly makes light of arbitrarily proposed principles. Eastern wisdom . . . A Korean converted to Catholicism who has since taken vows under the auspices of the preaching friars, the Dominicans, he left Seoul for Paris thirty years ago now. An exile from a country where calm mornings are savoured, he traded his East for a homeland vast in a different way, sometimes even wild: and there he linked to the life of God and that of the universe. Devoting himself to his calling with the appetite of a decoder of harmonies, he transcends the religious reality with design and flies in the face of the supernatural with brushstrokes and pigments.[51]

This ability to unite opposites, which we have discussed previously, acquires a special relevance with regard to his double condition, as a brother and as an artist: it turns him into a meaningful figure, in which two circles, that are sadly separated in present times, come together: 'First and foremost, Kim En Joong is certainly an ecclesiastic. He is also, and this is no small thing, for him or his contemporaries, a painter. A painter every God-given day.'[52]

Whether his religious work is confronted with mistrust in the world of contemporary art, or whether his modernness arouses incomprehension in certain ecclesiastical circles, he always presents his work without the slightest complex. 'Kim En Joong's work speaks of this world and its modernity, but it is first and foremost imbued with a strong and generous faith.'[53]

51. K En Joong, *Bruxelles-Paris*, 14.
52. K En Joong, *Les Retrouvailles* (París: Cerf, 2007), 12.
53. 'L'œuvre de Kim En Joong parle de cet univers et de cette modernité, mais elle est aussi et surtout imprégnée d'une croyance forte et généreuse.' G. Danneels, K En Joong, *Ave María* (París : Cerf, 2000), 7.

By doing so, he has achieved great recognition in both environments. Thanks to his talent, associated with the bravery and simplicity that characterize him, he has torn down the walls of prejudice which, with regard to Christianity, so often enclose modern cultural circles, and he has succeeded in showing a different side of the Church, one that is fresh and in keeping with today's world:

> Extremely well known today, Kim En Joong has exhibited his paintings in both Europe and Asia and there are numerous experts who recognise in him not a more or less inspired apostle of the Scriptures but a visual artist who, through a rare stroke of genius, will have succeeded in once more bestowing a favourable image on religious art, which has long awaited resurrection.[54]

Pe Kim's work has captivated the world of contemporary art and has done so without giving up its spiritual and faithful content at any moment. Indeed, references to Christian motifs are frequent in his paintings, namely in exhibitions such as the Twelve Apostles, the Ave Maria or the Beatitudes, thus underlining the topicality, the necessity and the significance of contemporary religious art: 'Father Kim's painting is not only the expression of an artist, it is above all the presence of a prayer to God.'[55]

On another hand, there are numerous relevant voices, including in the heart of the Church, that praise his artistic expression and know how to appreciate it:

> Father Kim's works, in their moderation, in their discretion, speak in a humble way of the greatness of their divine origin. God himself has revealed it to us, and has given us an example thereof by incarnating himself and becoming a man like one of us. The peaks of art are those that know how to come closest to the mystery of greatness and simplicity that is the Holy Incarnation.[56]

54. K En JOONG, *Bruxelles-Paris*, 14.
55. 'La Peinture du Père Kim n'est pas seulement une manifestation d'un artiste, elle est, surtout, la présence d'une prière vers Dieu.' K. Dae Joong in K En Joong, *Kim En Joong: Rouen*, 4.
56. 'Les œuvres du père Kim, dans leur retenue, leur discrétion, parlent d'une manière humble de la grandeur de leur source divine. Dieu lui-même nous l'a révélée et

And at the same time, its spiritual significance is recognised, its value as preaching, as a theological offer embedded in present days: 'Brother Kim does not claim to be a master of words. He speaks of his faith through his painting.'[57]

A reflexion on God, when it comes to be expressed, cannot be reduced to an exclusively verbal communication, and even less so nowadays, since our contemporaries are weary of discourses and have come to mistrust speeches. Our artist 'finds the words just as apt and tension-filled as his brushstrokes, and silence just as deep and knowing, when necessary. From the visible to the invisible, there are few ways to sing the essence of the world and he knows it, acting and painting as a result. His only concern: 'To express the passage of time towards Eternity".[58]

In turn, the Dominican's paintings address our sensitivity and intelligence, enabling everyone to approach the Evangelical message:

> Laid out on the ground of a former refectory converted into a studio of wealth, his canvasses are spread out seemingly as far as the eye can see and beyond. Put up, they call to mind the architectural flights of the 'Maisons de Dieu'. Warm and vibrant colours from a hand that enters excesses, outbursts, regrets and temporary procrastinations followed by increased energies. And, party to the same sense of spirit, large portions of the canvas are left deliberately blank . . . Thus each day, plays out a battle on the line between a man smitten by signs and the plainsong he offers us as a gauge of his overwhelming faith in an infinite Light.[59]

Kim's work shows us that it is still possible for art and faith to meet: by giving back its value to the spirituality that is inherent to any art, and that is too often forgotten in present times, stifled and lost amidst the voracity of the market; by offering faith a language that is modern and full of new possibilities for celebration, prayer and predication.

nous en a donné l'exemple en s'incarnant et en devenant homme comme nous. Les sommets de l'art sont ceux qui savent s'approcher le plus de ce mystère de grandeur et de simplicité qu'est la sainte Incarnation.' K En Joong, *Kim En Joong: Paris-Tokyo*, 13.
57. K En Joong, *Bruxelles-Paris*, 17.
58. K En JOONG, *Les Retrouvailles*, 15.
59. K En Joong, *Bruxelles-Paris*, 17.

'His paintings immerse us in nature, its spaces, its backwashes, and its flights. We are within, living, alert.'[60]

In addition, as an intermediary between the two worlds, it opens the door to believers to the possibility of learning, of interpreting and opening up to the languages and images of modern culture, in order to connect and to harmonise at last the aesthetics of our Christian dimension with the other facets of our lives, as people of the twenty-first century.

> However, a work of art cannot live only off the messages it strives to convey. It must innovate and clearly transcribe its time, give something to see, give to the heart and to the mind, thus falling within a broader time frame and testifying for the future.[61]

But understanding new forms of expressions is also indispensable for the Church to be able to listen to what today's human beings have to say. It is by those means that wishes and dissatisfactions are brought to light, that unfair and despicable situations of our world are denounced. Contemporary art is the first to show the clamour of our people, a speech which our Church must answer, and it must do so by using the same tools with which it is addressed, as is the case with our artist:

> A lover of lines, volumes and tensions in the call of the soul, he devotes his energetic aim of enlightening us to a faith, an enthusiasm and an availability as strong as it is generously chromatic, to his omnipresent apostolate. And what's more, he has been this way for more than a quarter of a century.[62]

The work of this brother-artist is an optimal example of the hope that the fruitful alliance which existed for centuries between faith and painting might become a realityonce more: 'Who said religious art was dead?'[63]

60. K En Joong, *Les Retrouvailles,*
61. 'Cependant, une œuvre ne peut vivre seulement des messages qu'elle souhaite délivrer. Elle doit innover et transcrire clairement son temps, donner à voir, donner au cœur et à la pensée, s'inscrire ainsi dans un temps plus long et témoigner pour le futur.' K En Joong, *Kim En Joong: Paris-Tokyo*, 13.
62. K En Joong, *Bruxelles- Paris*, 15.
63. K En Joong, *Les Retrouvailles,* 15.

Corollary

We find ourselves confronted with a work that is not only embedded in our times because of its form, of its abstraction, but first and foremost because of its contents.

With regard to the means of expression, we are faced with a language that is still unusual in the Church. A novel path to speak about God, that requires the believing spectator to reconsider his traditional codes of comprehension, to open his mind by leaving behind the 'commonplaces' of faith; it implies freeing himself from the unconscious routines with which he approaches the mystery, thus enabling a continuity, a growth in his relationship with God.

In addition to serving as evidence of the topicality of the Christian message, this work leads the faithless observer to an inner questioning, thus raising him beyond concrete, sensitive, and daily matters, towards the field of transcendence.

Regarding the contents, we have successively discussed along these pages how Pe Kim's creations are invitations for the spectator to take an active part in the reading of his art, to open up to spirituality and dialogue, and to carry on in search of Truth, of joy and optimism. Consequently, we may conclude that his painting is precisely that: a proposal, a suggestion.

Indeed, it acknowledges and respects the new faith-based sensitivity, that no longer obediently accepts the beliefs of past generations and that does not experience faith as a social imposition either. Nowadays, believers exercise their freedom to embrace a faith that they have discovered on their own and into which they have entered voluntarily.

But this artwork also aims to deal with one of the major shortcomings of our 'developed' societies: the lack of spirituality.

To face this reality, Pe Kim discreetly places before our eyes the suggestion of a path towards God devoid of forcefulness or abruptness, full of passion and strength.

Starting from the consideration of any given personal reality, even amidst the infinity of interpretations that each person may give his canvases, it is always possible to find some deep form of admiration and, from there, a path that originates in oneself, in the most intimate corners of one's mind and heart, in the beauty of creation.

And all this is filled with luminosity, uncovering the nonsensicality and dullness of our world's dark sides, and revealing to the present-day man, who is excessively used to screens, neon lights and fireworks, how much he is in need of true light.

A light that is Christ and around which, just like colours on a canvas, all dimensions of a person and all aspects of life can be brought into harmony: they are set into motion, they evolve, transform, and expand.

The work of our artist, by eluding any kind of concreteness, testifies of the fleetingness of material things, which must not be absolutised as they distract us from what is authentically important and definitive.

In this way he states the greatness of a God whom no one can limit or contain, who is always a step further, yet who must constantly be sought after. In this dynamic process which opens a door to transcendence, Pe Kim involves all of mankind, inviting each and everyone to set himself into movement, towards himself and towards the other, to save what all beings have in common, to achieve unity and, consequently, to find God.

Both the important message of the Dominican and the art with which he conveys it are warmly welcomed, as well in the ecclesiastic field as in the artistic one, thus not only showing that a reconciliation and cooperation between the two spheres is possible, but also that the Christian message remains perennially relevant.

Bibliography

Sources:

Benedicto XVI, *Catecismo de la Iglesia Católica*. Compendio, Asociación de Editores del Catecismo, Madrid, 2005.

Concilio Vaticano II, *Documentos*, BAC, Madrid, 1993.

Juan Pablo II, *Alocución a los obispos de la Conferencia Episcopal Toscana, 14 de Septiembre 1980*. https://w2.vatican.va/content/ john-paul ii/es/homilies.index.html#homilies

Juan Pablo II, *Catecismo de la Iglesia Católica*, Asociación de Editores del Catecismo, Madrid, 1992.

Juan Pablo II, *Carta a los artistas*, Vaticano, 4 de abril de 1999. http://w2.vatican.va/content/john-paul-ii/es/letters/1999/ documents/hf_jp-ii_let_23041999_artists.html

Juan Pablo II, *Carta Apostólica del 3 de octubre de 1982* en AAS 75 (1983) 796–799.

Mansi, JD (ed), *Sacrorum Conciliorum nova et amplissima collectio*, 31 vols., Florencia-Venecia, 1757–1798.

Migne, JP (ed), *Patrología Griega*, 161 volumes, Paris, 1857–66.

Migne, JP (ed), *Patrología Latina*, 217 volumes, París, 1844–55.

Pio XII, *Alocución del 20 de abril de 1955* en AAS 47 (1955) 285–292

Pontifico Consejo de la Cultura, *Via pulchritudinis. Camino de evangelización y diálogo, Asamblea plenaria 2006*, San Pablo, Madrid, 2008. http://www.vatican.va

Books:

AA.VV., *Arte y fe. Actas del congreso de 'Las edades del hombre'*, Fundación las Edades del Hombre, Salamanca, 1995.

AA.VV., *El gran arte en la pintura*, Vol. VI, El renacimiento I, Salvat, Barcelona, 1987.

AA.VV., *El Rosario de María, IV Congreso del Rosario*, San Esteban, Salamanca, 2003.

AA.VV., *Fra Angelico and the Chapel of Nicholas V*, Musei Vaticani, Città del Vaticano, 1999.

AA.VV., *Gran historia universal: El renacimiento*. Vol. XIV, Planeta, Madrid, 1989.

AA.VV., *Grandes de la pintura*, vol II, no 51, Fra Angélico, Sedmay, Madrid 1979.

AA.VV., *Historia del arte Espasa*, Espasa Calpe, Estella, 2004.

AA.VV., *Historia del arte*, Vol 15, CSIC, Barcelona, 1991.

AA.VV., *Historia de la Pintura*, Vol.I, Plaza&Janes, Barcelona, 1978.

AA.VV., *Introducción general al arte*, Itsmo, Madrid, 1990.

AA.VV., Kim En Joong, *80eme Anniversaire Du Journal Chosun IlBo*, Yeobaek Media, Seoul, 2000.

AA.VV., *Kim En Joong*, Du Cerf, París, 1997.

AA.VV., *Proponer la fe hoy. De lo heredado a lo propuesto*, Sal Terae, Santander, 2005.

AA.VV., *Retablo de artistas*, OPE, Caleruega, 1987.

AA.VV., *Santo Domingo de Guzmán. Fuentes para su conocimiento*, BAC, Madrid 1987.

AA.VV., *Doctrina de Catalina de Siena*, Arquidiócesis de Puebla (ed.), Puebla, 1980.

Aguilar, J de, O.P., *Temas actuales de arte sacro*, Casa de oración, Madrid, 1967.

Alberigo, J, Conciliorum Oecumenicorum decreta, Herder, Bolonia, 1973.

Alce, V, O.P., *Homilías del Beato Angélico*, Studio Domenicano, Bolonia 1983.

Alce, V, O.P., *Vita, opere e teologia del Beato Angélico*, Studio Domenicano, Bologna, 1993.

Alce, V, O.P., *Homilías del Beato Angélico*, Studio Domenicano, Bolonia, 1983.

Aldazábal, J, *Gestos y símbolos*, Centre de Pastoral Litúrgica, Barcelona, 2003.

Ancilli, E, *Diccionario de espiritualidad*, V. III, Herder, Barcelona, 1984.

Anderson, R, *Calliope s sisters: A Comparative Study of philosophies of art*, Englewood Cliffs, NJ, Prentice-Hall 1990.

Aquino, Sto. Tomás de, *Suma Teológica*, 4 Vols., BAC, Madrid 1988.

Argan, GC, *Fra Angelico et son siècle*, Editions Verdier, Genève-Paris-New York, 1955.

Arnheim, R, *Arte y percepción visual*, 2 ed., Alianza, Madrid, 2002.

Basch, M, *Teorías del arte: de Platón a Winckelmann*, Alianza, Madrid, 1944.

Baudelaire, CH, *Salones y otros escritos sobre Arte*, Visor, Madrid, 1992.

Bazín, G, *Historia del arte. De la prehistoria a nuestros días*, Omega, Barcelona 1976.

Bedouelle, G, *Historia Ilustrada de la Iglesia, los grandes desafíos*, San Pablo, Madrid, 2004.

Belda, Plans, J, *Historia de la teología*, Palabra, Madrid, 2010.

Benedetti, A, *Il linguaggio delle nuove Brigate Rosse*, Erga, Genova, 2002.

Bergua, JB, *Pitágoras, Ibéricas*, Madrid, 1995.

Bernardini, C, *Klimt, Rayuela*, Valencia, 1992.

Bodei, R, *La forma de lo bello*, Visor, Madrid, 1998.

Bonhoeffer, D, *Vida en comunidad, Sígueme*, Salamanca, 2003.

Cantró Rubio, J, *Evangelizar con el arte*, PPC, Madrid, 1990.

Cañón Loyes, C, *Matemática, la creación y descubrimiento*, Universidad Pontificia Comillas, Madrid, 2008.

Cárcel, V, *Historia de la Iglesia*, Vol III, La Iglesia en la época contemporánea, BAC Madrid, 1999.

Casado, M, *Cantaré tus alabanzas: selección de poesías para orar*, Rialp, Madrid, 2006.

Casás Otero, J, *Belleza y vida de fe*, San Pablo, Madrid, 2009.

Castañóm, D, O.P., *Historia de la Orden de Predicadores*, Edibesa, Madrid, 1995.

Castro, SJ, *En teoría, es arte. Una introducción a la estética*, San Esteban-Edibesa, Salamanca-Madrid, 2005.

Cheng, F,-En Joong, K, *Lumière*, Galerie Chave, Vence, 2015.

Cheng, F,-En Joong, K, *Quand les âmes se font chant*, Edition Bayard, Paris, 2014.

Cheng, F, *La Joie, En écho à une oeuvre de Kim En Joong*, Editions du Cerf, Paris, 2010.

Congar, YMJ, O.P., *Vatican II. Le Concile au jour le jour*, Éditions du Cerf, Paris, 1963.

Colorado Castellary, A, *Introducción a la historia de la pintura. De Altamira al Guernica*, Síntesis, Madrid, 1997.

Coomaraswamy, AK, *La filosofía cristiana y oriental de arte*, Taurus, Madrid 1980.

Corbí, M, *Religión sin religió*n, PPC, Madrid 1996.

Coutagne, D, *Cézanne abstraction faite*, Editions du Cerf, Paris, 2011.

Coutagn, D, Kim En Joong-*Selon Les Écritures*, Institut Kim En Joong, Vence, 2015.

D urso, G, O.P., *La spiritualitá del Beato Angelico*, Cantagallo, Siena, 1983.

Danneels, G-En Joong, K, *Ave María*, Editions du Cerf, Paris, 2000.

Danneels, G-En Joong, K, *La Croix*, Editions du Cerf, Paris, 2005.

Danneels, G-En Joong, K, *La Résurrection-De Verrijzenis*, Editions du Cerf, Paris 2010.

Danneells, G, *Quatre-vingts*, Editions du Cerf, Paris, 2013.

De Aguilar, JM, *Temas actuales de arte sacro*, Casa de Oración, Madrid, 1967.

De Capua, R, *Vida de santa Catalina de Siena*, Espasa-Calpe, Buenos Aires, 1947.

De Francesco Vega, C, *Las Iglesias orientales católicas*. Identidad y patrimonio, San Pablo, Madrid, 1997.

Dinzelbacher, P, Diccionario de la mística, Monte Carmelo, Burgos 2000.

Eaton, MM, *Art and Nonart: Reflections on an Orange Crate and a Moose Call*, Rutherford, New Jersey, Fairleigh Dickinson University Press 1983. Eckhard, M, *El fruto de la nada y otros escritos*, Siruela, Madrid, 2008.

Eco, U, *Historia de la belleza*, Lumen, Barcelona, 2004.

Eliade, M, Imágenes y símbolos, Taurus, Madrid 1974.

En Joong, K, *Bourges 2012*, Editions du Cerf, Paris, 2012.

En Joong, K, *Bruxelles-Paris, Expositions du jubilé de l'an 2000*, Editions du Cerf, Paris, 2000.

En Joong, K, *De la terre au ciel. Lettres au Père Albert Patfoort*, Editions Yeobaek, Seoul, 2014.

En Joong, K, *Kim En Joong: Rouen-Paris–Mechelen*, Editions du Cerf, Paris, 2010.

En Joong, K, *Kim En Joong-Vitraux, Stained glass*, Editions du Cerf, Paris, 2009.

En Joong, K, *Kim En Joong*, Editions du Cerf, Paris, 1997.

En Joong, K, *Kim En Joong: Paris-Tokyo-Séoul 2004*, Editions du Cerf, Paris, 2004.

En Joong, K, Les Retrouvailles, Editions du Cerf, Paris 2007.

En Joong, K, *Opere recenti*, Centro umanistico incontri internazionali, Bellona, 2001.

En Joong, K, *Resonnances*, Editions du Cerf, Paris, 2007.

En Joong, K, *Unity for peace. Grace Cathedral exhibition*, Ed. Grace Cathedral-Yeobaek Media Co, San Francisco-Seoul, 2002.

Fallani, G, *Il Beato Angelico, La capella di Niccolo V*, Editalia, Roma, 1955.

Fernández, A, Bernechea, E, Haro, J, *Història de l art*, Vicens Vives, Barcelona, 1992.

Flamand, E, *Historia general de la Pintura: El renacimiento I*, Aguilar, Madrid, 1969.

Fleming, W, *Arte, música e ideas*, Interamericana, México, 1971.

Formaggio, D, *Arte*, Labor, Barcelona, 1976.

Foucart, B, *Le renouveau de la peinture religieuse en France 1800–1860*, Arthéna, Paris, 1987.

Freeland, C, *But is it art?An introduction to Art Theory*, Oxford University Press, Oxford and New York, 2001.

Gadamer, HG, *Arte y verdad de la Palabra*, Paidós, Barcelona-Buenos Aires-México, 1998.

Garcia Mahíques, R, *Iconografía e iconología*, 2 Vols., Encuentro, Madrid 2009.

Garcí Martiníz, JA, *Arte y pensamiento en el siglo XX*, Editorial Universitaria de Buenos Aires, Buenos Aires, 1973.

Garcia Villoslada, R, *Historia de la Iglesia Católica*, II, BAC, Madrid 2009.

Garvie, AE, *Historia de la predicación cristiana*, Cie, Tarrasa (Barcelona) 1987.

Gelabert, M, *La Revelación, acontecimiento con sentido*, San Pío X, Madrid, 1995. Gilbellini, R, *La teología del S.XX*, Sal Terrae, Cantabria, 1998.

Gimémez, C, y Gale M, (eds.), Brancusi C, *The Essence of Things*, Catálogo exposición, Londres, 2004.

González, Arintero, J, *Cuestiones místicas*, BAC, Salamanca 1920.

González –Carvajal, L, *Ideas y creencias del hombre actual*, Sal Terrae, Santander 1996.

Girard, R, *El chivo expiatorio*, Anagrama, Barcelona, 2002.

Greco, A, *La cappella di Niccolo V del Beato Angelico*, Instituto Poligrafico E. Zecca dello Stato, Roma, 1980.

Hertz, A y Neels Loose, H, *Fra Angelico*, Paoline, Roma, 1983.

Hinnebusch, WA, *Breve historia de la orden de predicadores*, San Esteban, Salamanca, 1982.

Huyghe, R, *El arte y el hombre*, Planeta, Barcelona, 1977.

Illanes, JL y Saranyana, JI, *Historia de la teología, Sapientia fidei, serie de manuales de teología*, BAC, Madrid, 1996.

Iturgaiz, D, *Beato Angélico. Patrono de los artistas plásticos*, OPE, Burgos, 1997.

Iturgaiz, D, *El Angélico. Pintor de Santo Domingo de Guzmán*, San Esteban, Salamanca, 2000.

Jedin, H, *Manual de historia de la Iglesia*, Vol IV, Herder, Barcelona, 1986.

Juan de la Cruz, *Obras*, Monte Carmelo, Burgos 1943.

Juan Pablo II, *¡Levantaos! ¡Vamos!*, Sudamericana, Buenos Aires, 2004.

Jung, CG, *El hombre y sus símbolos*, Paidós, Barcelona, 1995.

Kadinsky, A, *De lo espiritual en el arte*, Labor, Barcelona, 1977.

Keller, CH, *Brioude, la basilique Saint-Julien dans la lumière de Kim En Joong*, Editions du Cerf, Paris, 2009.

Keller, CH, *La basilique Saint-Julien de BRIOUDE et les vitraux de Kim En Joong-Guide du Visiteur*, Editions du Cerf, Paris, 2009.

Laboa, Juan María (ed.), *Historia de la Iglesia. Desde los orígenes del cristianismo hasta nuestros días*, San Pablo, Madrid, 2012.

Lagier, JF, *Les Peintres & Le Vitrail. Vitraux français contemporains*, Centre international du Vitrail, Chartres, 2014.

Laurent, MC, *Valor cristiano del arte*, Casal i Vall, Andorra, 1960.

Lavergens, S, *Art sacré et modernité. Les grandes années de la revue L'Art sacré*, Lessius, París, 1999.

Lecrecq, H, *Diccionario de Arqueología y de Liturgia, VII*, Letouzey et Ané, París, 1953.

Lederach, JP, *El abecé de la paz y los conflictos*, La catarata, Madrid, 2000.

Lloyd, CH, *Fra Angelico*, Phaidon, Oxford, 1997.

Luci-Smith, E, *Artes visuales en el siglo XX*, Konemann, Colonia, 2000.

Ludvovic, SS, *Fra Angelico*, La Bibliothèque des Arts, París, 1955.

Marchese, V, *Memorie dei piu insigni pittori, scultori e architetti domenicani*, 2 Vols. Biblioteca Nazionale Centrale di Firenze, 1845.

Mardones, JM, *Matar a nuestros dioses. Un Dios para un creyente adulto*, PPC, Madrid, 2007.

Marino, E, O.P., *Beato Angélico.umanesimo e teología*, Postulazione Generale dei Domenicani, Roma, 1984.

Martín, F, *Historia de la Iglesia*, Vol. II, La Iglesia en la época moderna, Palabra, Madrid, 1999.

Martinéz, F, *¿Quién eres tú Domingo de Guzmán?*, Equipo PJV Dominicos y Dominicas, Madrid, 2015.

Martinéz, F, *Domingo de Guzmán. Evangelio viviente*, San Esteban, Salamanca, 1991.

Michaux H,-En Joong, K, *Noir et Blanc*, Galerie Chave, Vence, 2009.

Morante, E, y Baldini, U, *L'opera completa dell Angelico*, Rizzoli, Milano, 1970.

Nolan, A, *Esperanza en una época de desesperanza*, Sal Terrae, Santander, 2010.

Nougués, VM O.P., *La predicación a través del arte de fray Guillermo Butler, O.P.*, UNSTA, Tucumán, 2013.

Orlandis, S, *Beato Angelico*, Olschki, Florencia, 1964.

Orlandis, J, *Historia de la Iglesia*, Vol. I, La Iglesia antigua y medieval, Palabra, Madrid, 1998.

Papa Francesco, *La mia idea di arte, a cura di Tiziana Lupi*, Musei Vaticani-Mondadori, Città del Vaticano-Milano, 2015.

Pichaud, JCI, *Kim En Joong et le Cabanon de Saint-Paul*, Editions du Cerf, Paris, 2013.

Pijoan, J, *Historia del mundo*, Vol. IV, Salvat, Barcelona, 1961.

Pio XII, *Beato Angelico: Discurso de S.S. Pio XII en el V Centenario de Fray Juan de Fiesole*, Altamira, Madrid, 1957.

Pierenne, J, *Historia universal, las grandes corrientes de la historia*, Vol II, Éxito, Barcelona, 1972.

Plató, *La República*, Vol II, libro X., Edito. 74, Valencia, 2015.

Plató, 'Timeo', en Plató, *Obras completas*, Aguilar, Madrid, 1974.

Plazaola, J, *Arte sacro actual*, BAC, Madrid 2006.

Plazaola, J, *Estética y vida cristiana*, Universidad Iberoamericana, México, 1998.

Plazaolo, J, *Historia del arte cristiano, Sapientia fidei, serie de manuales de teología*, BAC, Madrid, 1999, 328.

Plazaola, J, *Historia y sentido del arte cristiano*, BAC, Madrid, 1996.

Pope-Genesi, J, *Angelico*, Becocci Editore, Firenze, 1981.

Rabade Romeos, S, *Guillermo de Ockham y la filosofía del siglo XIV*, CSIC, Madrid, 1966.

Rahner, K, *Dio e Rivelazione. Nuovi Saggi VII*, Edizione Paoline, Roma, 1981.

Rodin, A, *El Arte*, Aguilar, Buenos Aires 1951.

Rosmini, A, *Las cinco llagas de la santa Iglesia*, Península, Barcelona, 1968.

Salaverri, JM, *La anunciación, conversaciones con Fray Angélico*, PPC, Madrid, 1998.

Sesé, J, *Historia de la espiritualidad*, EUNSA, Pamplona, 2005.

Tamayo-Acosta, *Los sacramentos, liturgia del prójimo*, Trotta, Madrid, 1995.

Taurisano, I, O.P., *Beato Angelico*, Fratelli Palombi, Roma, 1955.

Teresa de Jesús, *Obras completas*, BAC, Madrid, 1979.

Thuillier, J-En Joong, K, *Rêves de Couleurs*, Editions Pierre Chave, Vence, 1992.

Thuillier, J, Kim En Joong-Peintre de lumière (Biographie), Editions du Cerf, Paris, 2004.

Vasari, AG, *Le vite dei piu eccellenti pittori, scultori e arquitetti* Vol. II, R.G.T.E.N, Roma, 1993.

Von Balthasar, HU, *Mysterium Salutis II*, Cristiandad, Madrid, 1977.

Articles:

Aleixandre, D, 'María: Magnificat realizado en ella', en, *Misión Joven* 352 (2006): 49–57.

Borrás Gualis, GM, 'Pintura', en AA.VV., *Introducción general al arte*, Alianza, Madrid, 1990, fourth edition, 197–277.

Centi, T, O.P., "La teología di San Tommaso nell'arte del Beato Angelico" en *Sapienza* 8/2 (1955): 153–157.

Colella, R, 'The Cappella Niccolina, or Chapel of Nicolas V in the Vatican: The history and significance of its frescoes', in AA.VV., *Fra Angelico and the Chapel of Nicholas V*, Ediurcula, Ciudad del Vaticano, 1999, 22–71.

Eckhart, M, 'Instrucciones Espirituales, en Jeanne' Ancelet-Hustache, *Eckhart y la mística renana*, Aguilar, Madrid 1962.

Falasca, S. "Beato Angélico: el realismo de la experiencia", en *30 días* 19/12 (2001): 46–51.

FALASCA, "La fides romana fuente de caridad", en 30 días, 19 (2001) n.12, 52–57. Falcào, JA, 'Arte y fe (Siete reflexiones en homenaje a Romano Guardini)', en *Conmunio*, 4(2001): 417–423.

Huguet, A. 'Teología del arte y mística de la pintura en fra Angelico de Fiesole', en *Teología espiritual* 4/10 (1960): 79–91.

Marabini, L. 'Beato Angelico e l arte evangelizzatrice', en *Culturas y Fe* 17/2 (2009): 118–124.

Martínez, Díez, F, O.P., 'El ministerio de la predicación', en *Studium*, 32(1992): 283–321.

Salaverri, J, 'Conversando con Fray Angélico', en *Miriam 55/ 327–328* (2003): 921–00.

Sánchez, JJ, «Símbolo», en C Floristán y JJ Tamayo, *Conceptos fundamentales de pastoral*, Cristiandad, Madrid 1983, 1296–1308.

Sanchez Andreu, JJ, 'Fray Angélico: la teología hecha pintura', en *Teología espiritual* 41/122 (1997): 167–190.

Scudieri, M. Gli affreschi del Beato Angelico: una lettura spirituale, en Cortesi, A-Tarquini, A, *Teoologia dell incarnazione oggi. Dio dell`umanità, umanità di Dio*, Nerbini, Firenze 2007, 248–429.

Venchi, I, O.P., 'The blessed Angelico and the Chapel of Nicholas V: Fra Angelico s Theology of art', en AA.VV., *Fra Angelico and the Chapel of Nicholas V*, Editrice Vaticana, Ciudad del Vaticano, 1999, 10–21.

Web Sites:

http://landru.i-link-2.net/shnyves/Art_in_Meditation.html

http://landru.i-link-2.net/shnyves/The_Face_of_Christ.html

http://members.aol.com/jocatholic/catholic.htm

http://ssnet.org/links/files/judeochristian.html

http://www.aphids.com/cgi-bin/relres.pl?M0=B&act=N3

http://www.artcyclopedia.com/feature-2000-04-links.html

http://www.artchive.com/juxt/passion/passion.html

http://www.artesacro.org.ar/

http://www.clark.net/pub/webbge/jesus.htm

http://www.christusrex.com/

http://www.fabiobodi.it/

http://www.kimenjoong.com/
http://www.smc.qld.edu.au/relart.htm
https://3danabenedicta.wordpress.com/
https://art3dana.wordpress.com/author/3danabenedicta/
https://www.youtube.com/watch?v=ap66sWDvzrI
https://www.youtube.com/watch?v=oA-_gvML1xc
https://www.youtube.com/watch?v=QyELKe3dz6M
https://youtu.be/3Lut8NOqyPo

For a full list of Pe Kim En Joong's art, paintings, ceramics and stained glass windows, please visit www.kimenjoong.com

CPSIA information can be obtained
at www.ICGtesting.com
Printed in the USA
FFHW020055310119
50288192-55324FF

9 781925 643992